IMAGES
*of America*

# THE CIVILIAN
# CONSERVATION CORPS
## IN LETCHWORTH STATE PARK

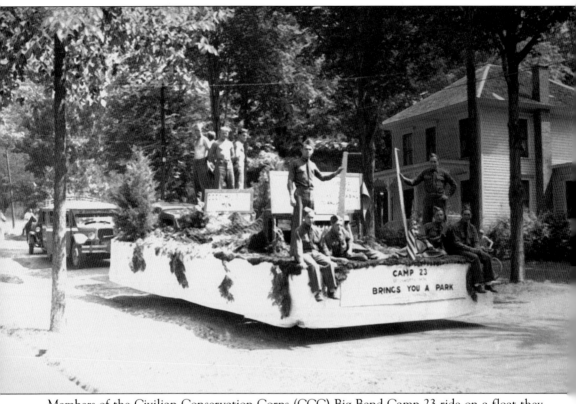

Members of the Civilian Conservation Corps (CCC) Big Bend Camp 23 ride on a float they constructed for a parade in Warsaw, New York. The float's signs say "Camp 23 Brings You A Park" and "CCC Camps Build Men." These two important goals of Pres. Franklin D. Roosevelt's Depression-era program were accomplished by the four camps that operated in Letchworth Park between 1933 and 1941. (Nunda Historical Society.)

ON THE COVER: Members of President Roosevelt's "Tree Army" practice marching behind their barracks at Big Bend Camp in Letchworth State Park. They carry axes, not guns, but their military-like determination, discipline, courage, and hard work resulted in the rapid development of the park and the creation of a generation of men whose motto was "We can take it!" (Letchworth State Park.)

IMAGES
*of America*

# THE CIVILIAN
# CONSERVATION CORPS
## IN LETCHWORTH STATE PARK

Thomas S. Cook

ARCADIA
PUBLISHING

Published by Arcadia Publishing
Charleston, South Carolina

Printed in the United States of America

Library of Congress Control Number: 2014952485

For all general information, please contact Arcadia Publishing:
Telephone 843-853-2070
Fax 843-853-0044
E-mail sales@arcadiapublishing.com
For customer service and orders:
Toll-Free 1-888-313-2665

Visit us on the Internet at www.arcadiapublishing.com

*To all those who served in the Letchworth Park CCC camps
from 1933 to 1941 and those who keep their legacy alive*

# CONTENTS

# ACKNOWLEDGMENTS

I would like to thank the many individuals and organizations that made this book possible.

There are several individuals with Letchworth State Park who helped in various ways. Many thanks go to Richard Parker, assistant regional manager, Roland Beck, park manager, and Brian Scriven, historic site manager, Mary Jane Brooks, Sandy Wallace, Stephanie Spittal, Kent Cartwright, Marjorie Stone, and Louise Sporleder. Special thanks go to Charles King for reviewing materials and helping with engineering records.

Thanks also go to the Nunda Historical Society, as well as Karen Gibson Strang, Douglas Morgan, and Jane Schryver, who were always willing to share historical photographs and information. I also appreciate the assistance of historian Amie Alden and clerk Mary Beth Bimber of the Livingston County historian's office and historian Doris Bannister and deputy historian Cindy Amrhein of the Wyoming County historian's office.

Other individuals who have contributed to this work are my granddaughter Emily Cook, Claire and Joseph Breslin, Leonora Letchworth, Peter and Sally Humphrey, Katrina Van Arsdale Drouhard, Pat Davis, Ken Wallace, John Thomas, Gail Diemoz, Karen Russell, and Garland Cummings. Special thanks go to my friend and colleague Tom Breslin, who reviewed the chapters and provided both encouragement and helpful suggestions.

All of us are indebted to the CCC alumni and their families who have shared their stories and donated their photographs and memorabilia to Letchworth Park. Although a few of their names may appear in this work, each has contributed to this book and to the legacy of the Civilian Conservation Corps in Letchworth State Park.

I wish to express my gratitude to Sharon McAllister and the fine folks at Arcadia Publishing for the help in making this project a reality.

My wife, Anne, deserves special recognition and thanks for her patience, encouragement, and considerable assistance in this third Arcadia Publishing project.

Most images in this work come from the collections of Letchworth State Park, New York Department of Parks, Recreation, and Historic Preservation (LSP), and the Roy Gath Collection in the Nunda Historical Society (NHS). Unless otherwise noted, the other photographs are from the author's collection.

# INTRODUCTION

On March 31, 1933, Pres. Franklin D. Roosevelt signed the Emergency Conservation Work Act into law, creating one of his most successful and popular Depression-era programs, the Civilian Conservation Corps (CCC). During the nine-year life of the program, over three million young men enrolled. Those young men accomplished a remarkable number of conservation and development projects, leaving a legacy still felt throughout the United States.

Part of that legacy is found in Letchworth State Park. Much of the infrastructure and many of the facilities used by visitors today were created or developed by the young men who served in Letchworth Park's four CCC camps. According to the late Edward Hamilton, former general park manager and commissioner, these men "laid the foundation for the modern park."

These enrollees, as the CCC men were officially called, were part of a generation whose character is best described in a November 1934 report by Harley Potter, camp superintendent at the Big Bend CCC camp in Letchworth Park: "Our constant association with the men of the Civilian Conservation Corps, both in the camp and in the field, has taught us much. These men, taken from all walks of life and from all parts of the country, have shown a remarkable adaptability to environment and environmental conditions. Their tasks have not been easy, nor, in many instances, very pleasant, yet they have shown great fortitude and the strength of the old pioneer in carrying on regardless of obstacles." They certainly lived up to the CCC's motto, "We can take it!"

Letchworth Park has worked hard to ensure that the "We can take it" boys and their achievements are remembered and honored. Since 1983, the park has hosted an annual CCC alumni reunion for veterans and their families, created museum exhibits and narrative boards, and held historical talks and walks that explore the experiences and accomplishments of the young men who served in Letchworth Park. Additionally, local historians have complemented these efforts by researching and presenting different aspects of the CCC in Letchworth State Park. It is hoped that *The Civilian Conservation Corps in Letchworth State Park* contributes to these efforts to keep the CCC legacy alive.

This book provides the reader with an overview of the CCC experience in the park. Chapter 1 begins with a brief history of the park from its beginnings as William Pryor Letchworth's estate to the dark days of the Great Depression that threatened to derail plans for the young state park's future. Chapter 2 details the establishment of four camps within the park and their physical makeup. Life in the camps is the main topic of chapter 3, while the largest section, chapter 4, examines the work projects that each of the camps completed in the park. Finally, chapter 5 deals with both the closing of the camps and the legacy left behind.

The information and photographs found in this book come from a variety of sources. Background research on the CCC was based upon several of the fine general resources listed in the bibliography and through CCC Legacy, Inc., which has done wonderful work in keeping the memory of the CCC alive. Its website is listed in the bibliography section.

Material on the Letchworth Camps was obtained through the National Archives, New York State Archives, local newspapers, and the collections of the Nunda Historical Society. Most, however, comes from Letchworth State Park archives. The park's collection includes photographs and

records created or acquired by the park during the CCC era, donations of items and information by CCC veterans and their families, and other material collected by the park staff, including documentation of commemorations and reunions held since 1983. The size and condition of the collection is a tribute to several generations of Letchworth Park staff who have cared for it over the years.

Such a wealth of information provides a solid foundation to develop a book. It does also, however, present some challenges. Since it was not possible to include every interesting photograph or story in the book, a selection process had to be used. First, it was decided that only images from the Letchworth Camps would be used. Since many enrollees served in more than one camp during their time in the CCC, donations by veterans resulted in the inclusion of images from other CCC camps outside of Letchworth in the park's collection. Even though many of these photographs are fine depictions of CCC life and work, every attempt was made to limit the book's images to those from Letchworth Park. A second consideration in the selection process was an effort to include as many individuals as possible. These photographs tend to be more interesting and also reflect the human side of the story. But readers will find that the majority of the individuals that are found in the book are not identified. This is due to the fact that most are not identified on the original image, and those that are labeled often use only first names or nicknames. These have been included where possible.

It should be noted that there are few camp rosters found in the park's collection. Each covers a specific six-month period. Every six months, a group of CCC members left camp while new members enrolled, necessitating a constant revision in the rosters. Camp rosters do not seem to be among the holdings of the National Archives, but families can request individual records for family members from its holdings for a fee. Request forms and instructions can be found at the National Archives website.

There are a few other aspects of which the reader should be aware. Camp officers and technical supervisors were most often the ones identified by name in the park's collection of photographs and reports, but they often appeared with different titles and different camp assignments. This is because it was not uncommon for officers and the technical staff to be transferred between camps and positions, which accounts for some apparent discrepancies in the book.

Camp names can also be confusing. Since camps sometimes had more than one numerical designation, the book uses the camp's geographical names such as Big Bend or St. Helena. Since these names are still used in the park, these designations may help readers explore the CCC story during their next visit to Letchworth Park.

In closing, it should be noted that the CCC generation is quickly fading away. As described in the final chapter, the last Letchworth CCC reunion was held in August 2014. The enrollees' legacy, however, will continue to be honored and celebrated long after their passing. As long as there is a Letchworth State Park, these men and their remarkable story will be remembered.

# One

# A Park in Need

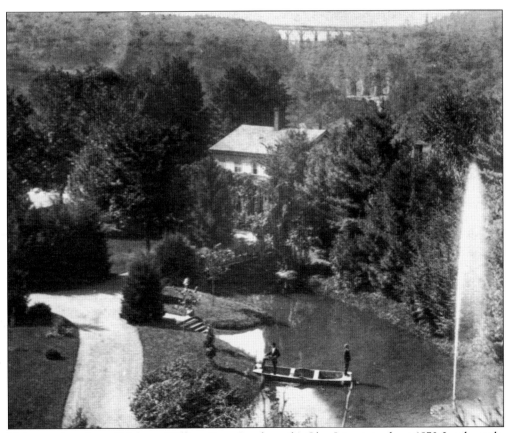

Visitors enjoy a beautiful day at William Pryor Letchworth's Glen Iris estate about 1870. Letchworth, a wealthy businessman from Buffalo, New York, purchased his first 190 acres along the Genesee River in 1859. Letchworth's home, now the Glen Iris Inn, can be seen in the center of the photograph. The nearby pond and fountain are still a favorite of visitors, but the wooden railroad trestle in the distance burned in 1875.

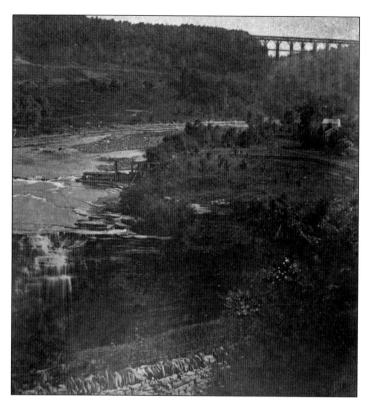

Once hidden behind sawmills and a bridge, the natural beauty of the Middle Falls (lower left) was slowly restored under William Pryor Letchworth's guidance, as this 1860s image shows. As the estate expanded to 1,000 acres, Letchworth constructed trails, culverts, overlooks, and stone walls in order to make the property safe and accessible to the public. One of his stone walls is partly visible at the bottom of the photograph.

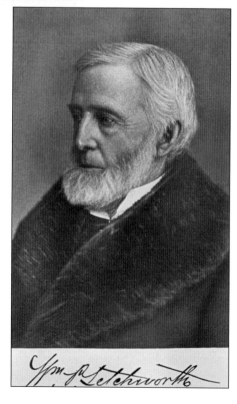

With his health failing and the Glen Iris estate threatened by plans to construct a power dam just south of the railroad bridge, Letchworth offered his Glen Iris estate to the State of New York in December 1906. The following month, Gov. Charles Evans Hughes called upon the state legislature to accept the "tract of rare beauty" as a public park for "the advantage and enjoyment of the people." (LSP.)

Governor Hughes signed the act creating the new state park in January 1907. Letchworth retained life use of his grounds, but after his death in 1910, the shift from a private estate to a state park began. The Letchworth Park Committee of the American Scenic and Historic Preservation Society oversaw the new park's transition for the next two decades. The committee published this brochure from the 1920s that calls the new park "a natural feature unsurpassed in scenic beauty of its kind in the eastern part of the United States." The task was to develop and modernize the park while maintaining William Pryor Letchworth's commitment to that natural beauty and the historical significance of the land.

# GUIDE TO
# Letchworth
# Park
## STATE OF NEW YORK

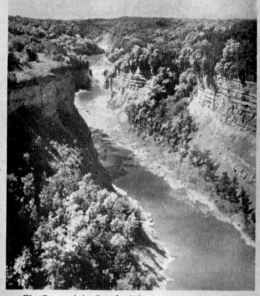

The Gorge of the Genesee River and the Middle Falls
in Letchworth Park

PUBLISHED BY

**THE AMERICAN SCENIC AND
HISTORIC PRESERVATION
SOCIETY**

(LETCHWORTH PARK COMMITTEE)

CASTILE, NEW YORK

———

PRICE, 10 CENTS

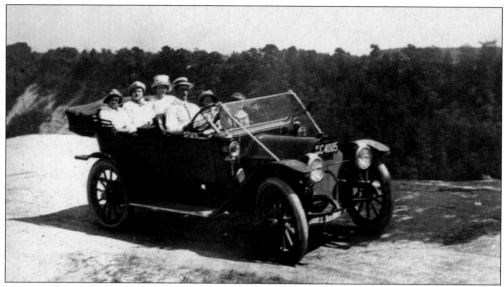

The greatest challenge came from the automobile. Where most 19th-century visitors had come on excursion trains, 20th-century tourists would arrive by car. The Corby family of Lima, New York, drives perilously close to the gorge in 1913. Four years later, 200 automobiles were counted on the Glen Iris lawn on the Fourth of July. The 1918 season averaged 800 cars a week. (Cathy Corby Gardener and Doug Morgan.)

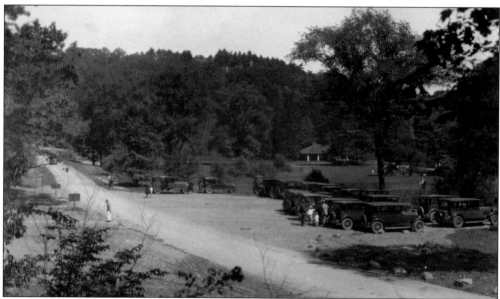

The Letchworth Park Committee responded with several development projects. One focused on the flats between the Middle and Upper Falls. In its brochure on the previous page, the committee calls the spot "one of the centers of attraction, and here on broad terraces there are ample parking and picnic spaces with tables, fireplaces and a refreshment stand." The 1913 comfort station seen in the distance in this early photograph is still in use today.

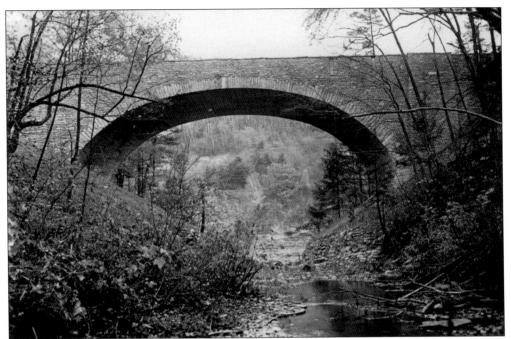

The park's road system was also improved and expanded. A major accomplishment by the Letchworth Park Committee was the replacement of an old iron bridge built by William Pryor Letchworth with the beautiful stone arch bridge over Dehgayasoh Creek, which still stands today. Although initially successful, the committee transferred control to the new Genesee State Park Commission in 1930, which continued the development of the park. (LSP.)

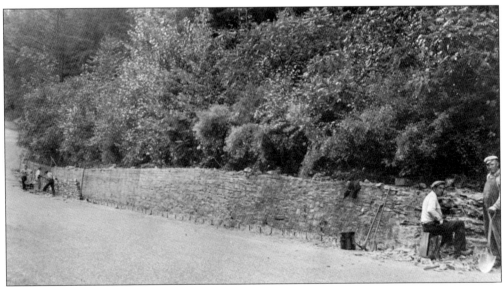

Park workers build a stone wall along the south entrance in September 1931. According to a newspaper article that year, the commission had plans for "new construction of permanent betterments" that would include new roads, picnic and camping areas, improvements to older roadways, new retaining walls and culverts, and the construction of log cabins to replace the old tents near the Lower Falls. (LSP.)

Tourists enjoy a Sunday afternoon at the Lower Falls on September 11, 1932 (above). By this time, the popular park was in trouble. As the Great Depression deepened, state funding was reduced to a trickle. Although extensive development plans remained on the books, there was no way to pay for them. Some funds did become available through the Temporary Emergency Relief Administration (TERA) created by Gov. Franklin Delano Roosevelt and the state legislature in October 1931. Although TERA funds allowed the park to employ local workers on projects such as road and wall work on Eagle Hill, it was clear that much more was needed (below). Help came in the form of the Emergency Conservation Work Act, which created the Civilian Conservation Corps. (Both, LSP.)

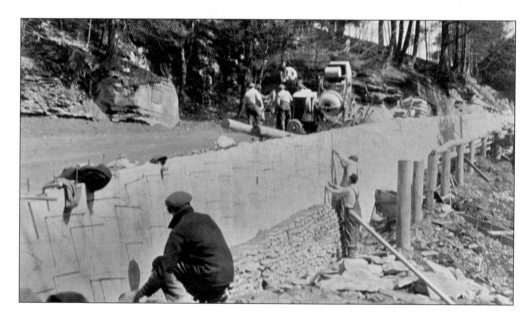

*Two*

# THE CCC CAMPS ARRIVE

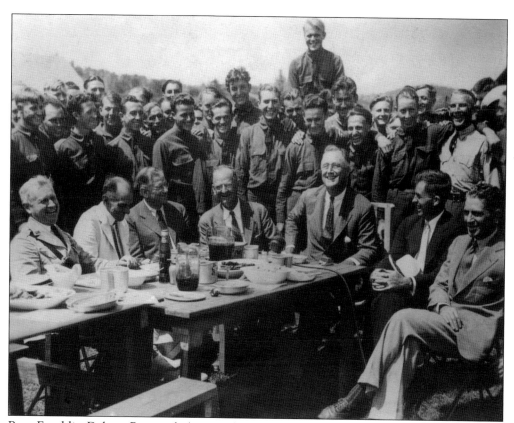

Pres. Franklin Delano Roosevelt (sitting third from right) enjoys lunch in August 1933 with members of the new Civilian Conservation Corps (CCC) at Big Meadows Camp in Virginia. The Emergency Conservation Work program was signed into law on March 31, 1933. By July 1933, there were 250,000 unemployed young men enrolled, including nearly 200 in Letchworth Park. CCC director Robert Fechner is on the president's right. (Franklin D. Roosevelt National Library.)

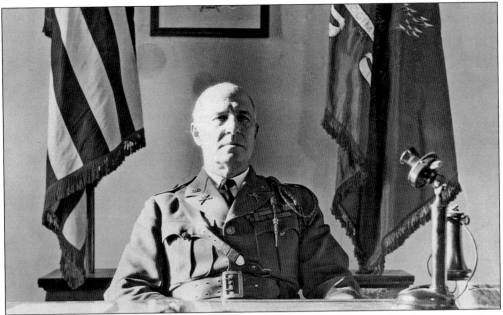

The Army was responsible for implementing the CCC program. Nationally, nine corps regions were established, with New York State part of the 2nd Corps area, which was divided into the Northern and Southern zones and several districts. Initially, any camps established in Letchworth Park would be in the Northern Zone, Fourth District, commanded by Col. Charles Morrow, shown here in the district headquarters at Fort Niagara in Youngstown, New York. (Old Fort Niagara Association, Inc.)

Local officials quickly realized the potential of the new program. Led by Charles Van Arsdale (top row, second from right) and Wolcott J. Humphrey (not pictured), the Genesee State Park Commission began working with federal officials to bring CCC camps to the Genesee Valley. Letchworth State Park would eventually be home to four camps. (LSP.)

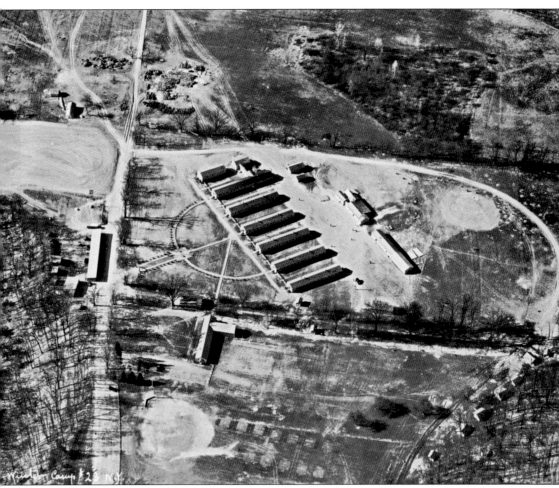

Several things factored into the placement of a CCC camp. The proposed site had to be on public lands near a railroad or highway, have potable water, and contain at least six acres of level land. The undeveloped Big Bend area on the east side of the park was selected for the first camp. Shown here in late 1933 or early 1934, the camp was well placed to carry out a variety of projects such as the cabins of Area E visible in the corner of the photograph. (LSP.)

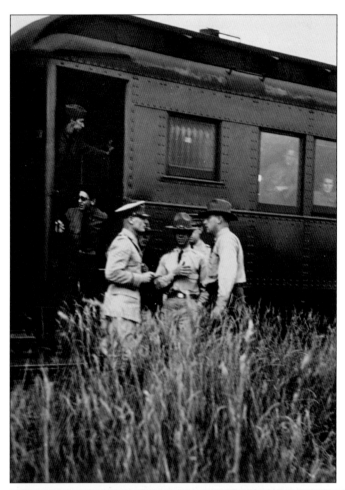

The first CCC contingent arrived at Letchworth State Park on June 19, 1933. A local newspaper reporter wrote, "The first detachment . . . had arrived that morning from Buffalo, coming by the Erie R.R. to Portageville and via foot to the camp." This undated photograph from the park's collection may document the arrival of the company at the station near the Portage Bridge. (LSP.)

The same reporter drove down a narrow road to reach the new camp where he "found a fine bunch of young fellows setting up a tent city." The tents would be home to the new company for several months. This photograph is dated September 14, 1933. Traces of this tent city are still visible in the photograph on page 17. (LSP.)

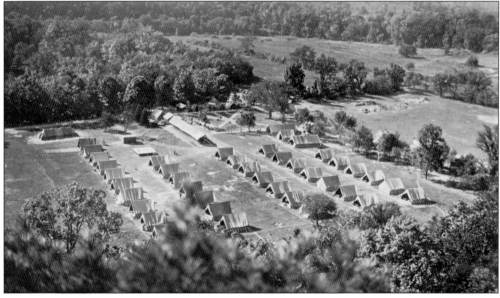

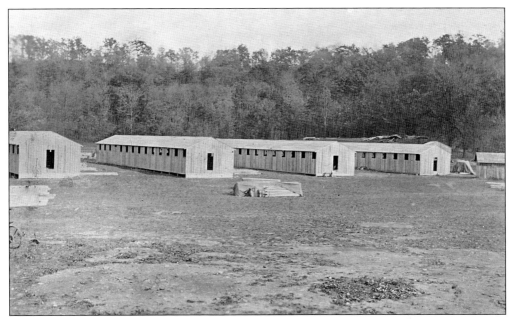

Later that fall, the tents had been replaced by wooden barracks and other buildings constructed under the supervision of contractor McKinley Gath of nearby Warsaw, New York. A formal dedication of the winter quarters was held on Tuesday, December 12, 1933. The ceremonies included a dinner and a speech by Congressman James W. Wadsworth. (NHS.)

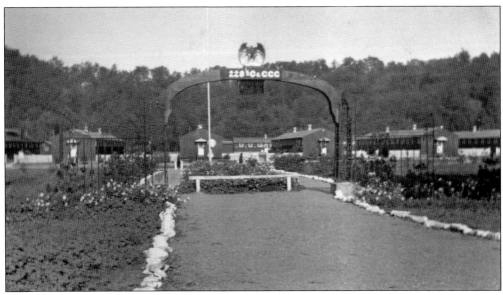

The signs on Big Bend Camp's gates read "Company 228." All the companies in the 2nd Corps area were numbered in the 200s. The camp was designated Camp 23, but it also was called SP 5, signifying it was located in a state park. The fancy gates and eagle had once been part of William Pryor Letchworth's Glen Iris estate and were loaned to the company by the park. (NHS.)

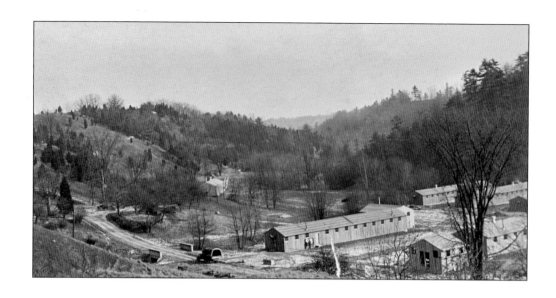

Work on a second CCC camp began in September 1933 along the Silver Lake outlet in the newly acquired northern section of Letchworth State Park (above). It was called the Gibsonville Camp after a vanished hamlet that once existed in the area. Once completed, it was officially known as Camp 40 or SP 17 (below). Company 213 was formed in November from an Adirondack Mountains camp and new enrollees from Camp Dix, New Jersey. The image below was taken in 1935. (Above, LSP; below, Karen Gibson Strang.)

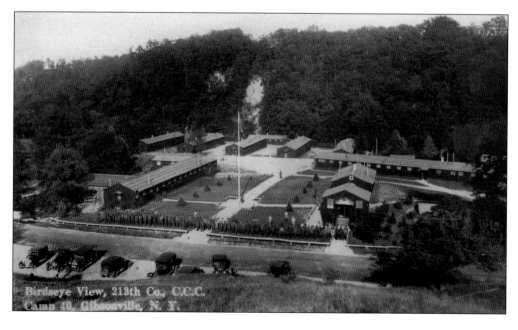

Birdseye View, 213th Co., C.C.C. Camp 40, Gibsonville, N. Y.

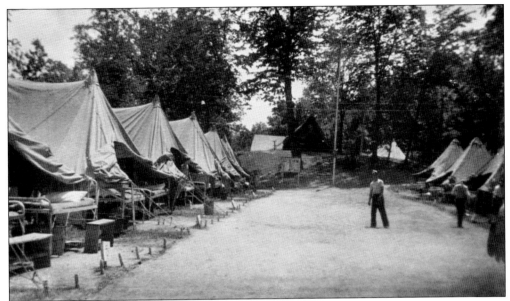

Another advanced detachment of CCC enrollees arrived in the park on May 17, 1934. Their job was to clear the site for what would become known as the St. Helena Camp. Soon, another tent city had appeared to house the rest of Company 264 that had come from a CCC camp in Damascus, Virginia, and Camp Dix, New Jersey. (LSP.)

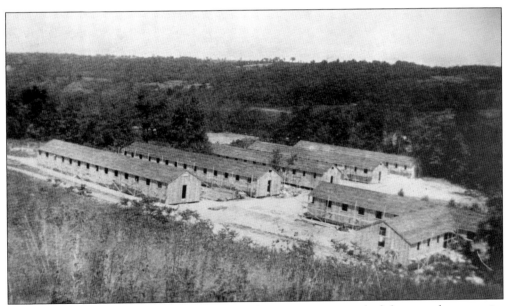

The new barracks at St. Helena, shown here under construction, marked the second community to be established at that spot in the Genesee Valley. A century earlier, pioneers settled the valley below the camp, establishing the thriving village of St. Helena. That community had disappeared by the time this new generation of pioneers arrived to leave their mark on the land. (LSP.)

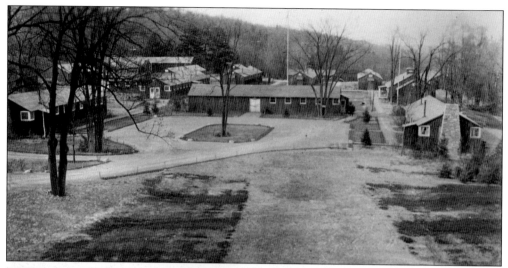

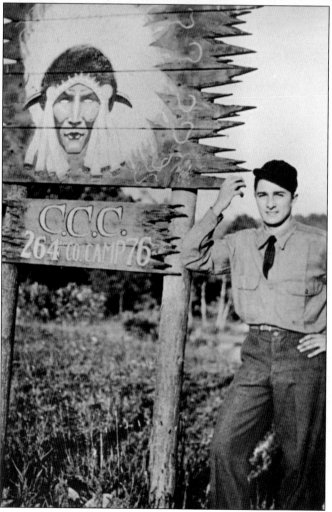

St. Helena Camp 76 (SP 37) was completed in September 1934 (above). On October 5, 1934, CCC officials, local community leaders, and 500 people gathered on the new camp's parade grounds to dedicate the camp. After opening the ceremonies, the commanding officer, Capt. Harry Richards, introduced Jesse Cornplanter and Nicodemus Bailey from the Seneca reservation at Tonawanda to officially dedicate the camp. Bailey expressed his gratitude to the CCC for helping his people; eight Native Americans were on the camp's roster. A member of Company 264 poses next to the camp's sign (left). Although the artist used a western headdress rather than a Seneca *gustoweh*, the connection to the valley's native history is clearly shown. (Both, LSP.)

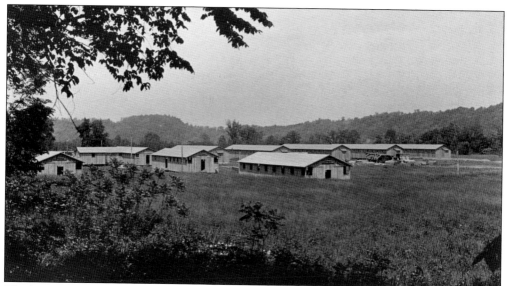

The last of Letchworth State Park's four CCC camps takes shape in the summer of 1935. Work had begun in the former farmer's fields near the river below the Lower Falls on May 27. On July 3 of that year, 170 men arrived by train, followed at 1:30 a.m. the next morning by a truck convoy transporting the rest of the company, their field tools, and camp equipment. (LSP.)

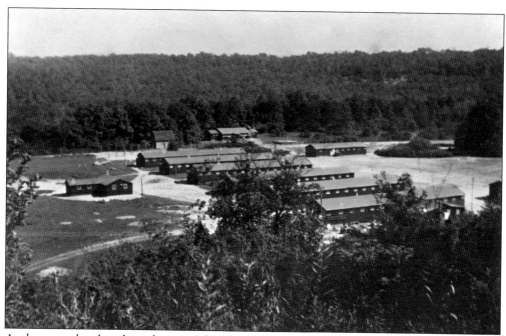

As they completed work on the camp's buildings, Company 201 also worked on a new road to the camp, improved the water supply to the area, and carried out other fieldwork. The camp, officially known as SP 49, was completed on July 22, 1935. The camp buildings shown in this photograph would play an important role in World War II. (LSP.)

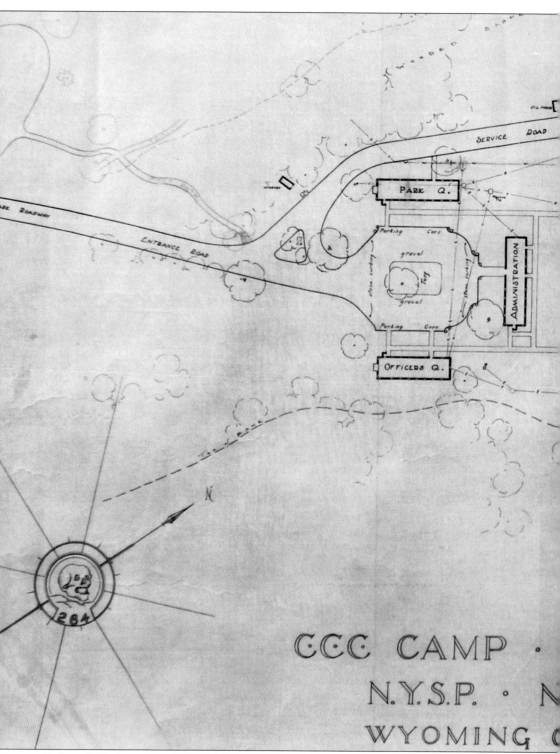

By June 1935, there were 19 CCC camps in the Fourth District, Northern Zone, 2nd Corps. Each camp had some individual differences in its physical appearance, but they generally followed a

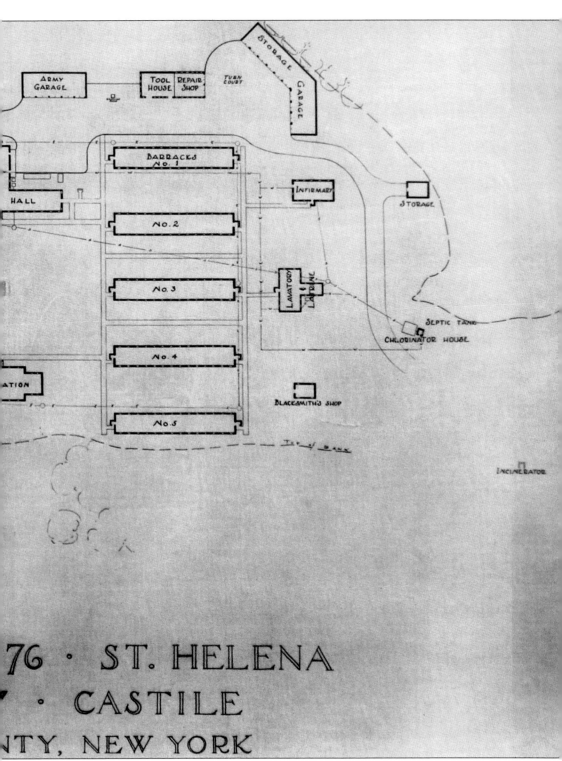

76 · ST. HELENA
· CASTILE
TY, NEW YORK

basic plan similar to the one shown here for the St. Helena Camp. The original camp plans for
three of the four Letchworth Camps are found in the park's engineering department. (LSP.)

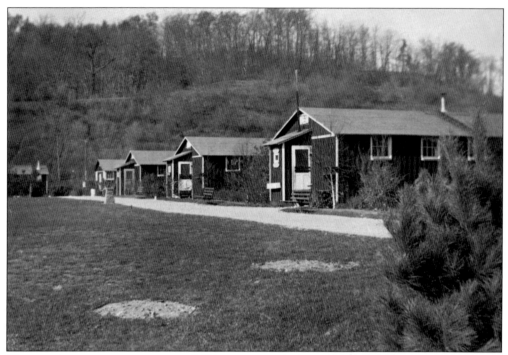

The most important structures in a CCC camp were the barracks. Each of the Letchworth CCC camps had five barracks holding up to 40 enrollees each, facilitating the standard 200-man quota per camp. The barracks at Lower Falls Camp shown here boasted a small entrance. Note the park benches in front of each barracks. (LSP.)

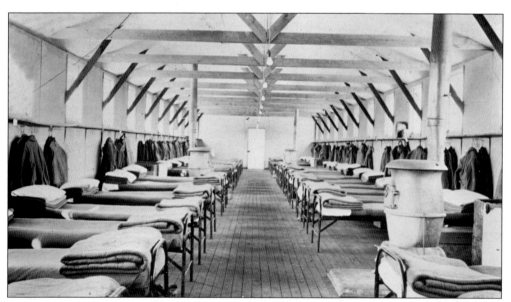

This photograph from the St. Helena Camp shows the interior of one of the barracks. Plenty of windows helped to cool the building in the summer, and stoves heated it through the winter. If it was the same size as the ones at Lower Falls, this barracks was 20 feet wide by 121 feet long. (LSP.)

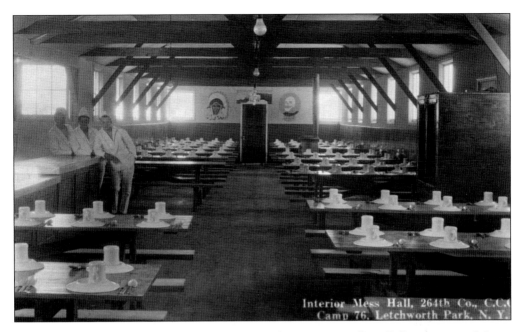

Interior Mess Hall, 264th Co., C.C.C.
Camp 76, Letchworth Park, N. Y.

Each camp had a mess hall that could seat all of the camp's enrollees. Following typical Army organization, there was a separate, smaller mess for officers and civilian officials nearby. The stewards have set the table for the next meal in the St. Helena Camp's mess hall (above). The camp's kitchen was attached to the mess hall. Cooks and kitchen helpers pose in what is believed to be the kitchen at the Gibsonville Camp (below). (Both, LSP.)

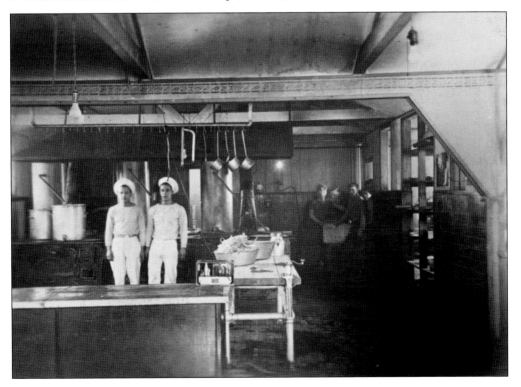

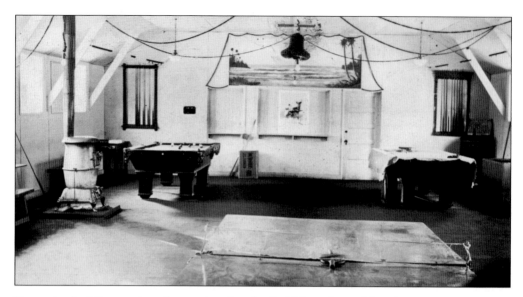

Recreation buildings such as the one found in the St. Helena Camp (above) were among the most popular spots in the camps. District headquarters provided "magazines, metropolitan newspapers, and radio receiver sets," but the recreation halls offered much more. Companies took pride in obtaining additional equipment such as the pool and ping-pong tables found in the St. Helena Camp recreation hall. The Gibsonville Camp did one better (below). Project superintendent Don Kessler reported in June 1935 that the camp was "fortunate in having a large auditorium, seating an audience of 500 people" in addition to its original recreation building. Basketball games were also played in the building; one of the hoops is visible on the wall over the folding chairs. Note the large stage, piano, and the company plaques on the wall. (Both, LSP.)

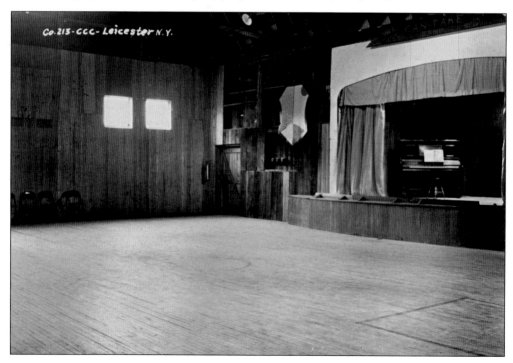

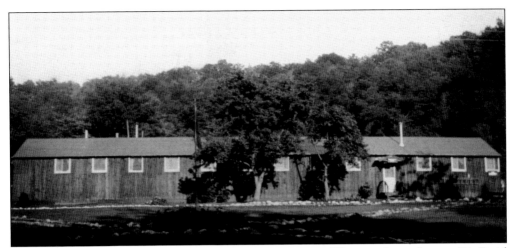

Officers and civilian administrators had their own quarters. The one shown here at Big Bend resembled a regular barracks on the outside, but it included the camp office at one end. Both this photograph and the one below were taken by CCC member Roy Gath. (NHS.)

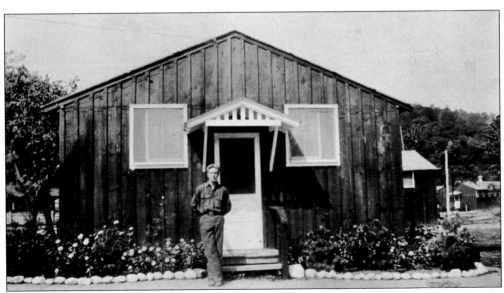

An enrollee, probably the company's clerk, poses outside the camp office at Big Bend. The office and officer quarters were set off from the regular barracks, which can been seen in the background on the far right. Note the flowers near the office entrance. Similar plantings were found throughout the camps. (NHS.)

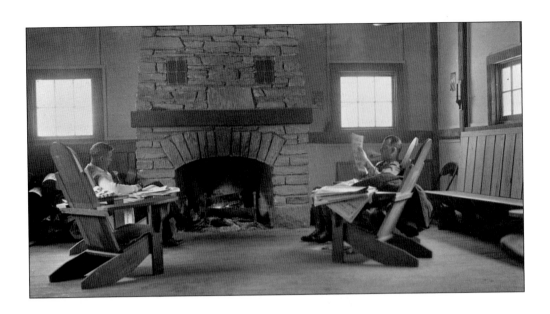

Gibsonville Camp officials relax in front of a stone chimney in a lounge that was attached to quarters for the officers and civilian officials (above). Around 10:00 p.m. on March 9, 1935, an overheated stove in the officer quarters caused a fire, which spread through the structure (below). Enrollees fought the fire as best they could, but the building containing their fire hose also burned. Fire companies from Perry and Leicester, New York, arrived in time to prevent the flames from spreading to other camp buildings. It was estimated that the fire caused about $2,000 in damages, including the personal possessions of the officers and other officials. This photograph was taken the morning after the fire. The stone chimney, visible on the right, survived and was used when the buildings were rebuilt. The chimney still stands today at Gibsonville. (Both, LSP.)

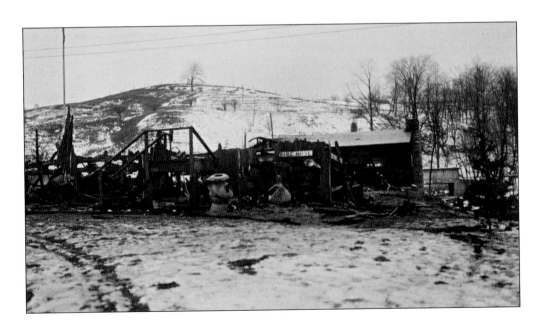

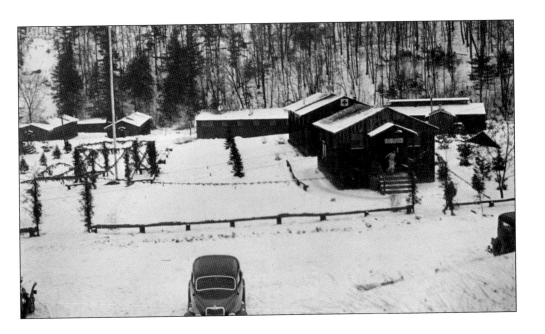

Headquarters served as a camp's center for both CCC members and visitors alike. Unlike the one in Big Bend Camp (page 29), the Gibsonville Camp office was in its own separate building, visible to the right of center. Behind the building is the camp hospital or infirmary. The photograph below shows the inside of the infirmary at St. Helena. The doorway to the right leads to the ward with several patient beds. A well-stocked medicine cabinet is seen to the left. When this photograph was taken, the desk belonged to orderly Leo Hankins. Patients with minor injuries or colds were treated by first aid attendants like Hankins, but an Army doctor also visited the camps on a regular basis. In case of emergencies, local physicians such as Dr. Schneckenburger of Nunda, New York, were on call. (Both, LSP.)

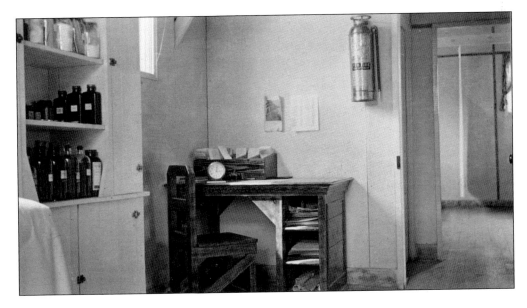

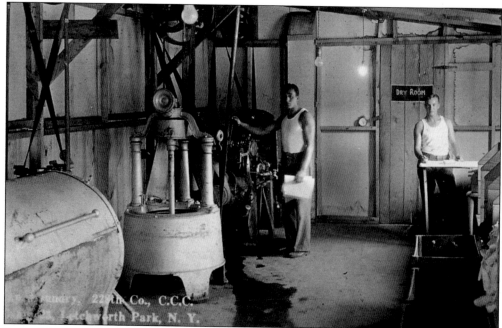

Each of the camps also had its own laundry facilities, such as the one in the Big Bend Camp shown here. This laundry had its own engine, which drove what appear to be two washing machines. A separate drying room was found beyond the far door. The Big Bend Camp also counted a bakery among its 18 buildings, which are listed in a December 1933 *Nunda News* article. (LSP.)

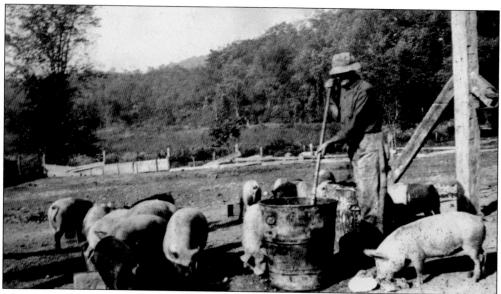

The same article identifies some of the other buildings and features useful to the successful operation of a CCC camp. These included a storehouse, latrine, horse barn, slaughterhouse, sheds for vehicles and equipment, and, at least at Big Bend, a pig pen. "Pops" Truman tends to the pigs at the camp in this photograph taken by enrollee Roy Gath. (NHS.)

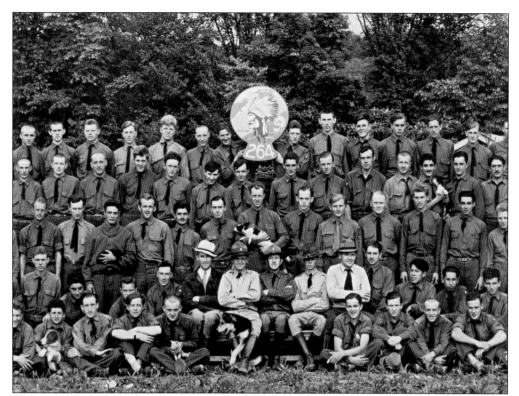

Residents of the camps fell into three groups. The largest was the enrollees, and then came civilian personnel and Army officers. All are represented in this portion of a photograph of St. Helena Camp's Company 264 taken on June 20, 1934. One might add mascots as a fourth group. Four dogs and two kittens are included in the company photograph. (LSP.)

Enrollees were male, unmarried, and between 18 and 25 (later 17 to 28) years of age. The federal Department of Labor carried out the selection of recruits through state and local relief agencies, so most of the members came from families that were receiving some sort of government relief. Some, like Roy Gath of Nunda, New York (pictured), came from small towns, while many came from cities. (NHS.)

5-11-36

# UNITED STATES DEPARTMENT OF LABOR
### EMERGENCY CONSERVATION WORK

## APPLICATION FOR ENROLLMENT

Date: May 9, 1936

APPLICANT'S NAME **Cook,        Stillman      Thomas**
                 (Last name)      (First)      (Middle initial)

ADDRESS **32 W. Railroad Street,**

POST OFFICE **Norwich,**

STATE **New York**        COUNTY **Chenango**

APPLICATION RECEIVED BY—

LOCAL AGENCY **Emergency Relief Bureau**

ADDRESS **City Hall,**

CITY OR TOWN **Norwich, New York**

Age **19**       Place and date of birth **Potsdam , New York**       **June 13, 1917**
                              (City and State)           (Month)       (Day)     (Year)

If not born in the United States,
have you been naturalized? **-**     First papers _____ Final papers _____
                                   (Date)            (Place)      (Date)

EDUCATION: [Circle highest grade completed] Grammar or grade school 1 2 3 4 5 6 7 8    High school 1 2 3 4    College 1 2 3 4

Other education **-**

State experience in club or community activities such as:
Red Cross, Boy Scouts, 4-H Clubs, etc. **-**

How long unemployed **one month**   Are you registered for work with the nearest public employment office? **NO**
                (Months)

Last job held **Farming**

Work best qualified for **Laborer**

Amount and kind of outdoor work experience **Lumberjack - 3 months**

What kind of a job do you hope to find after completion of C. C. C. enrollment? **Muscian**

Previously enrolled in
Civilian Conservation Corps? **no**      If so, state former
                  (Yes or no)      company location

Former company                  Former individual                                              ( HONORABLE
number_____           serial number_____    Type of discharge_____ (Check) ( ADMINISTRATIVE
                                                                 ( DISHONORABLE

Length of previous service _____ Date Enrolled _____ Date discharged _____
                  (Months)

ALLOTMENT OF PAY FROM MONTHLY CASH ALLOWANCE TO BE MADE TO DEPENDENT RELATIVES AS FOLLOWS:

Name **Mrs. Elizabeth Cook**          Relationship **Mother**

Address **Hogansburg, New York**        Amount **$25.00**

Name _____          Relationship _____

Address _____          Amount _____

The foregoing statements are true, to the best of my knowledge. If I am accepted and enrolled, I agree to abide faithfully by the rules and regulations governing the work and the camps in which I may be employed.

APPLICANT'S SIGNATURE *Stillman T. Cook*

## THE UNITED STATES DEPARTMENT OF LABOR

Certifies that **Stillman Thomas Cook,**
                                  (Name)
residing at **32 W. Railroad Street, Norwich, New York**
                                    (Address)
has been properly selected for enrollment in Emergency Conservation Work (Civilian Conservation Corps) and for the completion of his enrollment has been directed to report to U. S. Army authorities at **Hartwick New York.**

| NOTE: This form to be used only for "Juniors" |
|---|

TEMPORARY EMERGENCY RELIEF ADMINISTRATION
79 Madison Avenue, New York City
HENRY F. SHIPHERD—Special Representative, C.C.C.

By **Gordon R. Ingalls,**
                (Selecting Agent)
**Commissioner of Public Welfare**
                (Official designation)

TO ARMY

Stillman T. Cook, the author's father, filled out this CCC application in Chenango County, New York. The number of men each county could recruit was determined by population. All enrollees had to send $25 of their $30 monthly pay to their families. Initially, if an enrollee did not have family, it went to the relief bureau for some other needy family. Later, it was put into escrow. Enrollees signed up for a six-month period, but were limited to a total of two years of service. (National Archives Record Administration.)

Joe-Joe
Mouse
Oley
mely
Warren
Jr Bianca
Mame
Brogg
Pat Handy

Since CCC work was physically demanding, all recruits had to pass a physical examination. About 10 percent of the applicants failed, often due to tuberculosis, pneumonia, or other illnesses rampant during those hard economic times. Conditioning came next. In the first few years, 2nd Corps enrollees went to Camp Dix, New Jersey, where they went through a week of exercises and workout under the watchful eyes of Army drill sergeants. Unidentified members of the Big Bend Camp show off the results of their CCC conditioning in these two photographs taken by Roy Gath. (Both, NHS.)

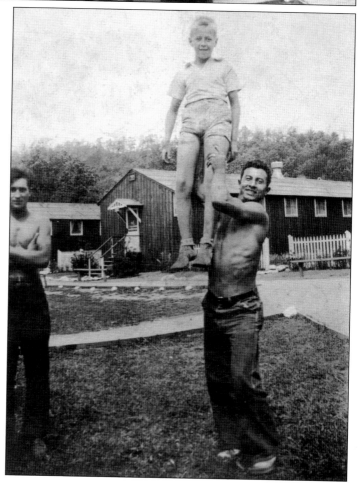

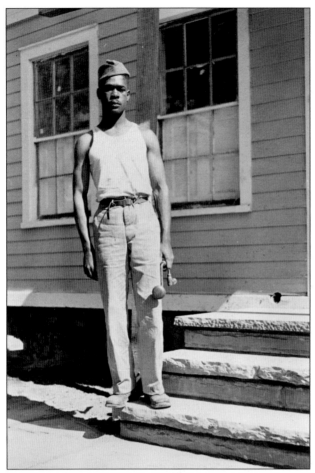

When the Emergency Conservation Works Act was debated, African American congressman Oscar De Base successfully added an amendment that banned discrimination in the CCC on the basis of race, creed, or color. Since segregation was not legally considered discrimination, separate black companies were formed with white officers. One such company was assigned to Gibsonville in 1937. An unidentified black enrollee stands on the steps of the park's office. (LSP.)

This photograph by Frances Sanfratelo is labeled "Young Indian Corps members from Towanda (Tonawanda?) Indian Reservation. Real good bunch of young men. 1934." An executive order on April 14, 1933, opened the CCC to Native Americans, and over 88,000 joined. Most worked on reservations, but some were assigned to camps such as St. Helena. (LSP.)

Each camp had a cadre of Army officers. Here Gibsonville Camp commander Capt. George W. Martin poses near Company 213's sign. Martin served as camp commander from February 1934 to his retirement in 1937. After a brief retirement in Geneseo, New York, Captain Martin formed a new company and was sent to a new camp in Oregon. The CCC's motto is partially visible on the sign. (LSP.)

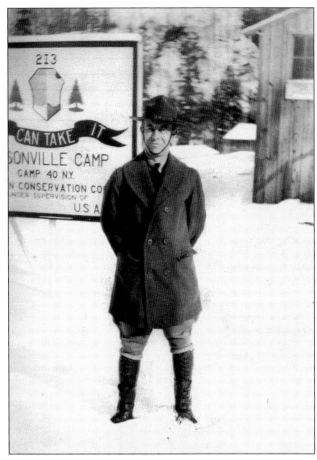

Civilians were part of every camp. Technical service supervisors planned and organized the work, while "Local Experienced Men" (LEMs) served as foremen and crew chiefs, training and overseeing enrollees on CCC projects. Their pay was higher and they did not have to make allotments. They also did not have to reenroll every six months as enrollees did. This group worked at the St. Helena Camp. (LSP.)

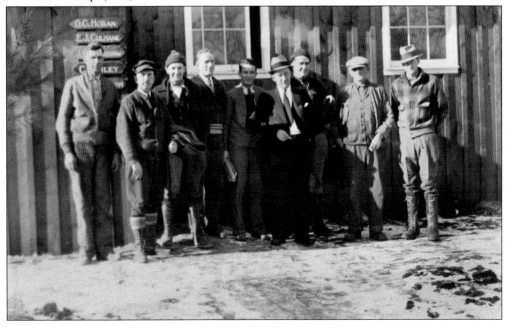

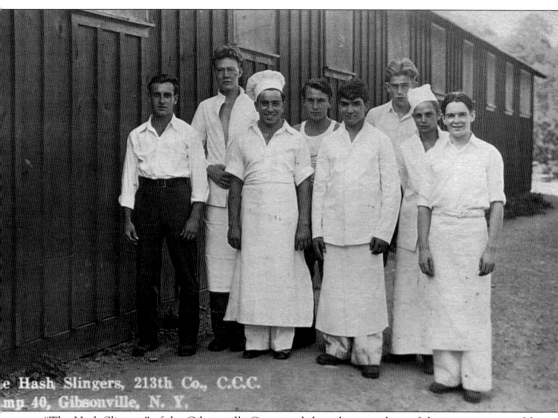

e Hash Slingers, 213th Co., C.C.C.
mp 40, Gibsonville, N. Y.

"The Hash Slingers" of the Gibsonville Camp and the other members of their company quickly settled into their new life as CCC enrollees. By August 1935, Gibsonville and the other Letchworth Camps—Big Bend, St. Helena, and Lower Falls—were in full operation with more than 800 enrollees, officers, civilian workers, and assorted mascots. It was a transformational time for the park, the men in the camps, and the surrounding countryside. The following chapters explore what life was like for the CCC men, the work they did, and their lasting legacy in the park. (LSP.)

## *Three*

# LIFE IN A CCC CAMP

According to *Your CCC, A Handbook for Enrollees*, "life in a CCC camp is a different kind of life than most boys have known." Enrollees such as these Barracks 3 buddies certainly discovered a whole new world in the Gibsonville Camp. Life in the camps would transform all the young men who served in the CCC. (LSP.)

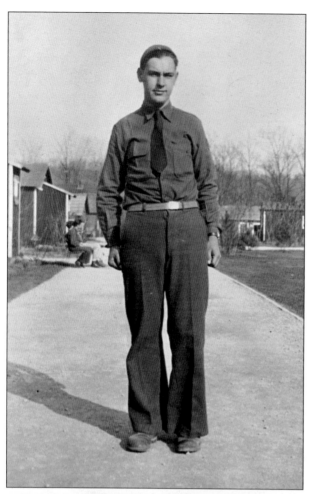

Robert Kirtland poses in the Lower Falls Camp in 1938 or 1939. Upon entering the CCC, the enrollees were issued two sets of clothing, a blue denim work outfit and a basic Army uniform for dress purposes. In January 1939, it was announced the CCC would get its own forest green uniform the following October. Kirtland may still be wearing one of the older uniforms in this photograph. (LSP.)

Work crews, such as this one from Big Bend, supplemented the basic issue with an assortment of clothing. CCC regulation originally required work shoes with leather soles. A 1936 memo from the 2nd Corps headquarters eased the rules and allowed the camps to experiment with composite soles. Soldiers in World War II wore composite-soled boots, partly the result of the CCC experiment. (NHS.)

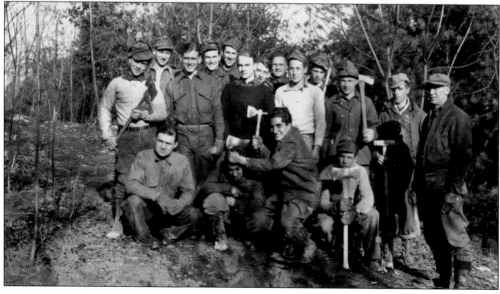

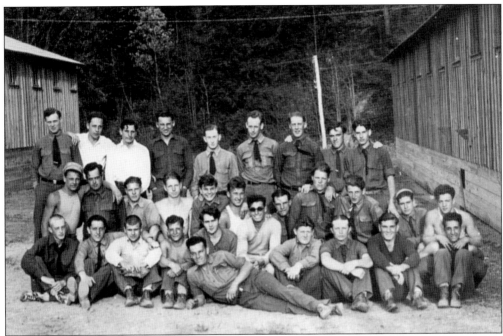

Each enrollee was assigned to a barracks, the basic social unit of every camp. In his barracks, each man learned to get along with others, sometimes forming friendships that would last a lifetime. Competition between barracks was often fierce, but good natured, as they vied in camp sports and for the best inspection rating. Above, enrollees of one of the Gibsonville barracks pose for a group photograph. Below, barracks members stand ready for inspection next to their cots in what is believed to be the Gibsonville Camp. (Both, LSP.)

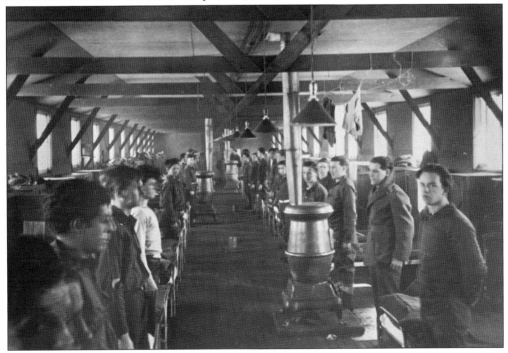

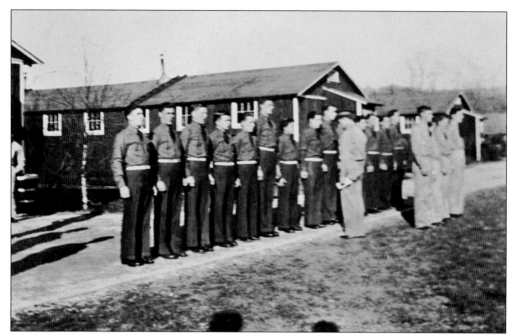

Enrollee Robert Kirkland may have surreptitiously snapped this photograph on the Lower Falls parade grounds, which he labeled "inspection by Lt. Coleman" (above). The CCC was often called the Forest or Tree Army for good reason. At first, the US Army was tasked with setting up camps, conditioning recruits, and transporting them to their assigned camps. President Roosevelt and Director Fechner realized that only the Army had the experience and resources needed to run the camps. The result was that Army organization, routines, and discipline would be part of CCC life. Camp commanders were responsible for camp operations and the welfare of all the men. Capt. Harry E. Richards (left) inspects some baking in the Lower Falls Camp kitchen (below). Lt. Frank S. Pederson, the camp's mess and post exchange officer, may be the officer on the right. (Both, LSP.)

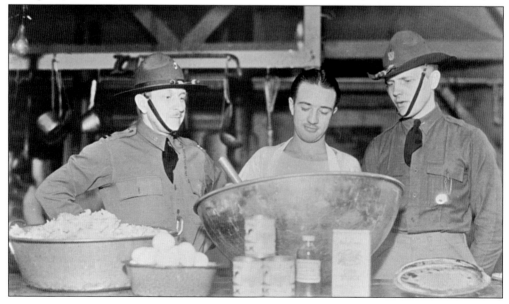

The success of the camp depended heavily on the quality of the skipper, as the camp's company commander was often known. It appears from contemporary records, newspaper accounts, and CCC veterans' memories that the Letchworth Camps had capable officers assigned to them. In command of Company 228 at Big Bend was 1st Lt. Joseph W. Kullman. Enrollee Roy Gath knew his skipper's name but not the correct spelling. (NHS.)

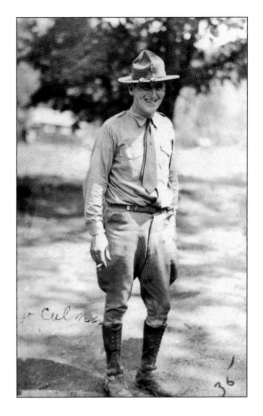

The commanding officer was assisted by several junior officers. Captain Martin (left) is shown here with two other Gibsonville officers, supply officer Captain McCormick (center) and mess officer Lieutenant Gay. Camps also had officers in charge of the post exchange, welfare, and transportation. Usually the junior officers took on more than one area of responsibility. About 97 percent of CCC officers nationwide were reserve officers. (Karen Gibson Strang.)

43

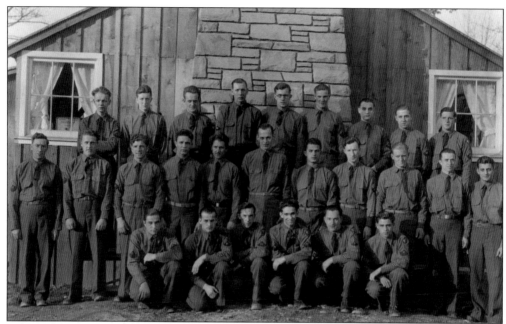

The Leaders' Club of Company 264 poses near the officers' quarters in the St. Helena Camp (above). These were individuals who were "given such authority and responsibility over and above that given the ordinary enrollee as their skill and leadership qualifications warrant." Each camp commander could appoint 26 enrollees as leaders or assistant leaders. According to 2nd Corps headquarters in 1936, a dozen could be assigned to the camp overhead details such as senior foreman, storekeeper, steward, first and second cooks, camp clerk, and truck drivers. The other 14 were assigned to work crews outside the camp. Leader John Capece (first row, second from right) whose identification card is shown below, would have earned an extra $15 a month. Capece's family, like many other CCC veterans' descendants, donated the photograph and the card to the park. (Both, LSP.)

**264th Company**

C C C

U. S.

**Castile, N. Y.**

NAME ___ John Capece _____

SERIAL NO. ___ CC2-59709 _____

RATING ___ Leader _____

DETAIL NO. _____

Central to life in the camp was the daily routine. Each company commander could set his own camp schedule, but the one used by the Gibsonville Camp was probably typical to most CCC camps. The day started early, with first call at 6:00 a.m., followed by reveille at 6:15 a.m. "Red" Archer sounds the bugle call at the Big Bend Camp in this photograph by fellow enrollee Roy Gath (right). Company 213 has gathered for a flag-raising ceremony in the Gibsonville Camp (below). Each camp had its own parade grounds area where the companies assembled for flag and other ceremonies. 2nd Corps headquarters also recommended that each camp hold 15 minutes of calisthenics, but morning exercises may have not been common in the Letchworth Camps. (Right, NHS; below, Karen Gibson Strang.)

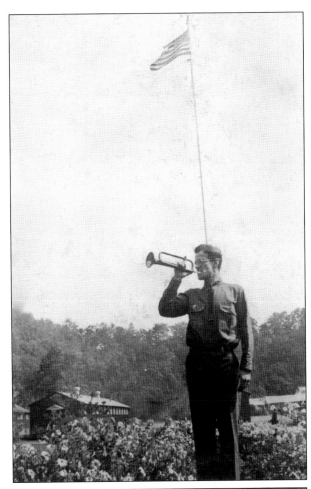

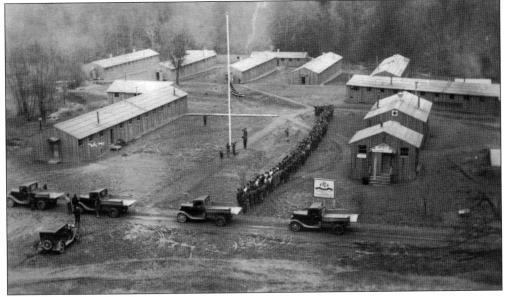

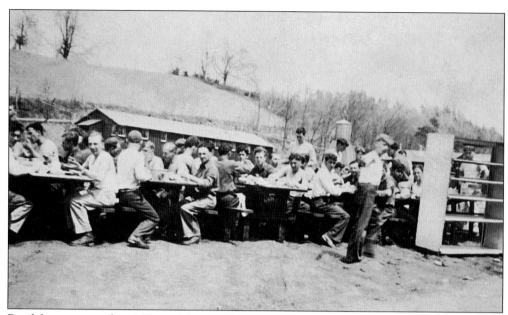

Breakfast was served at 6:45 a.m. Most meals were served in the mess hall, but in this Roy Gath photograph, men are eating outside. Enlistee Joe Cravotta recalls in the July 10, 1936, edition of the *Genesee Gazette* that at the Lower Falls Camp, "for the first couple months, meals were served outdoors due to the fact that the mess hall was not as yet completed." (NHS.)

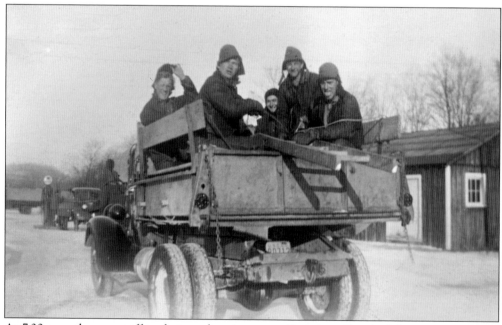

At 7:30 a.m., they were off to their work assignments. Some enrollees had duty assignments in camp, but the majority worked on projects in the park. Trucks carried them to the work areas far from the camp. These members of Company 201 at Lower Falls head off to work on a cold winter morning. (LSP.)

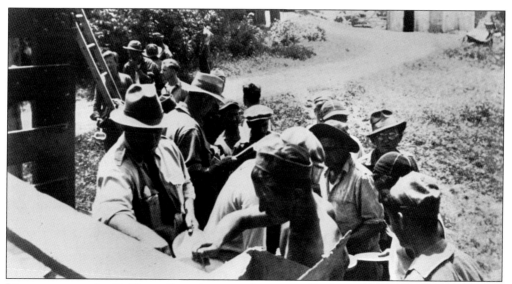

Dinner was served at 11:30 a.m. Sometimes a work crew would take packed lunches to the worksite, but often a truck would deliver the food to the crew. This work crew from Big Bend seems to be enjoying a hot meal served from the back of one of the camp's trucks. (NHS.)

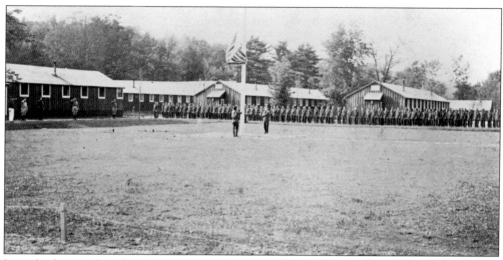

It was back to work in the afternoon until recall at 3:15 p.m. The enrollees then cleaned up from the day and relaxed until retreat at 4:55. Members of Company 264 gather for a flag ceremony on the parade grounds at St. Helena. Supper followed at 5:00 p.m. (LSP.)

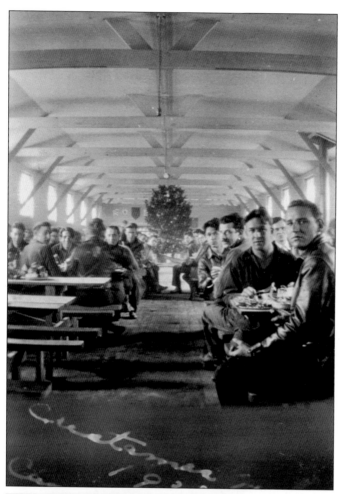

Men of the Gibsonville Camp enjoy a meal around Christmastime (left). By all accounts, the food at the Letchworth Camps was good and plentiful. A mess steward in Big Bend told some visitors in August 1934 that they "bake 220 loaves of bread every night, 1,400 cookies or cakes per day, 90 pies . . . 500 ears of corn, 700 hot dogs, 14 gallons of spinach, 12 gallons of cherries for pies, nine hams, and two bushels of beans." He added that they "raise their own garden vegetables at the camp." It is no wonder that on average enrollees gained 11 to 15 pounds in the first three to four months. Camp cooks "Casey and Jimmy" prepare a meal at the St. Helena Camp (below). (Both, LSP.)

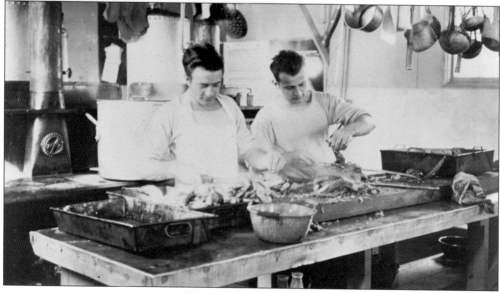

Evenings belonged to the enrollees. In the Lower Falls Camp, a popular evening hangout was the recreation hall, which housed the camp's canteen (above). The *Genesee Gazette* of August 1936 announces that "according to orders, Toots Santora's bright and smiling mug will beam at you over the canteen counter at the following hours," which included 5:50 p.m. to 9:00 p.m. on weekdays. One could buy soda pop, cigarettes, candy, and other small sundries. Alcohol was forbidden. Some, like these young men of the Big Bend Camp (below), chose to relax in the barracks doing some "educational" reading (a *True Story* romance magazine). Taps and lights out came at 10:00 p.m. Enrollee Roy Gath won a prize in a contest with this photograph. (Above, LSP; below, NHS.)

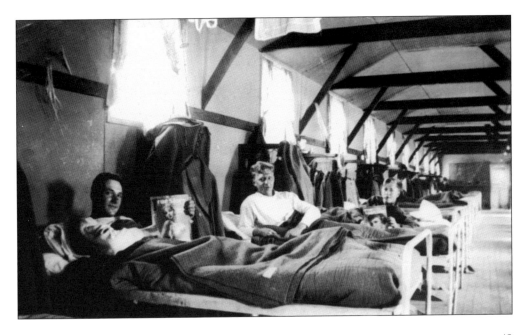

In addition to their regular work, enrollees had other jobs. "Shorty" is shown here working on the windows of his Lower Falls barracks. The detail sheet from the camp's Barracks 5 in January 1941 assigned members to clear ashes from stoves, dust, mop, fill coal bins, and fire buckets, line up beds, and sweep doorways. The warning "anyone not doing detail gets 4 hrs" is written on the sheet. (LSP.)

Camp 49 at the Lower Falls looks deserted in this photograph taken in April 1937. This could be a weekend when most of the camp headed out on leave. Those who lived nearby or had local friends sometimes did not return until late Sunday or early Monday morning. A small contingent remained in camp for maintenance, security, and fire protection. Sunday services were usually held at the camps. (LSP.)

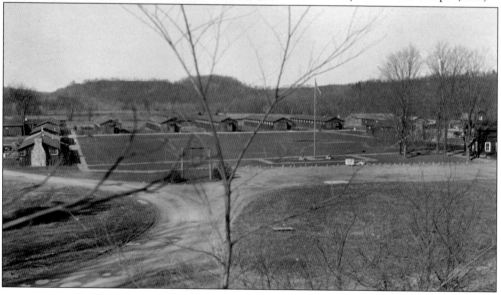

Capt. Harry Richards was remembered as a stern but fair disciplinarian. Maintaining discipline was a challenge in the CCC, as Richards and the other officers had no legal authority over the enrollees. Kitchen patrol (KP) could be assigned, leaves revoked, ranks reduced, or pay docked, but there was no brig and no physical punishment. Local law enforcement was called for criminal behavior, and the ultimate punishment was discharge from the corps. (LSP.)

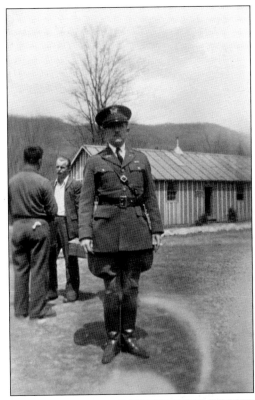

Peer pressure was useful in maintaining order. Although this photograph by Roy Gath of a Big Bend work crew holding court is probably staged, barracks mates and crew members found ways to take care of slackers and troublemakers. Most enrollees realized that life in the CCC was far better than the hard times many Americans faced. They had food, friends, work, and pay. They also had fun. (NHS.)

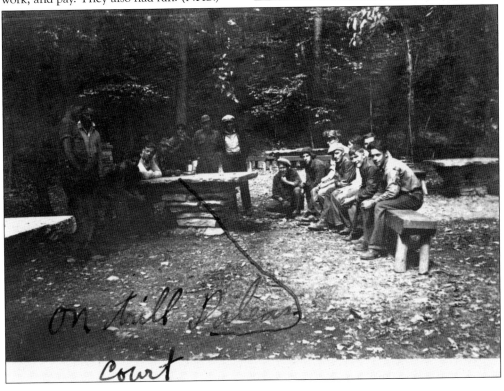

There was more to life in camp than routines, duties, and details. An enrollee plays his accordion at the Lower Falls Camp (above). Capt. Harry Richards would be pleased. In the July 24, 1936, issue of the *Genesee Gazette*'s The Skipper Says column, Richards writes, "I wish each man when his day's work was done could look forward with pleasure to hours that never hang heavy on his hands . . . to the pursuit of his hobby that will fill his idle hours with pleasure." Captain Richards felt this would benefit the camp as well. He continued, "It's a question of Company spirit . . . to take out the monotony and establish in its place interest and contentment." Organized activities like quoits (horseshoe) pitching, popular at Big Bend Camp, is one of his suggestions (left). (Above, LSP; left, NHS.)

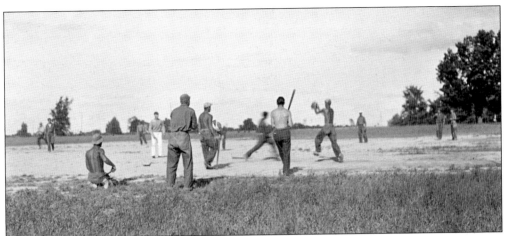

Captain Richards was not alone. A 1935 memo from 2nd Corps headquarters states that "all provisions (will be) made to provide wholesome and proper recreation for all during leisure hours and especially during inclement weather." Each camp would provide for "athletics, games, recreational equipment, mass singing, dramatics, gymnastics, calisthenics, hobbies, [and] arts & crafts." The baseball game at Gibsonville captured in this photograph from September 1935 fit this order. (LSP.)

Arts and crafts projects of CCC members from 17 western New York camps are seen in this photograph from the Buffalo Hobby Show held at the Elmwood Music Hall in March 1936. Two Letchworth enrollees won awards in leatherworking. Victor Hartung of Camp 49 (Lower Falls) won for a wallet and Frank Simon of Camp 76 (St. Helena) for a woman's handbag. Other local enrollees entered paintings, carvings, and metalwork. (LSP.)

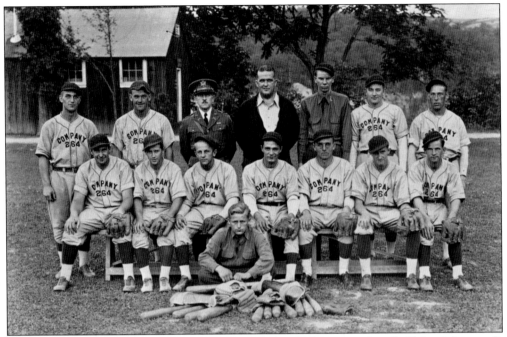

Sports were probably the favorite camp activity. Camp baseball teams, such as St. Helena's (pictured), played against area camps and took part in local town leagues. Standing next to Captain Richards in the back row is H.A. Brogan, one of the camp foremen who may have served as coach. The equipment was provided, but uniforms were purchased through donations and with profits from the camp's canteen. (LSP.)

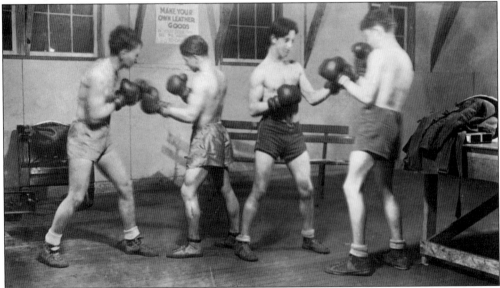

Camps also had softball, basketball, and boxing teams. Assistant project superintendent Tom Hance reported in February 1936 that "boxing has again attracted many members of the (Lower Falls) camp, practice being held regularly and frequently in preparation for the district title matches to be held next month." Pictured here, from left to right, are members of the Lower Falls' boxing team: Allen Pillard, John Vitale, Charles Allen, and Dick Donovan. (LSP.)

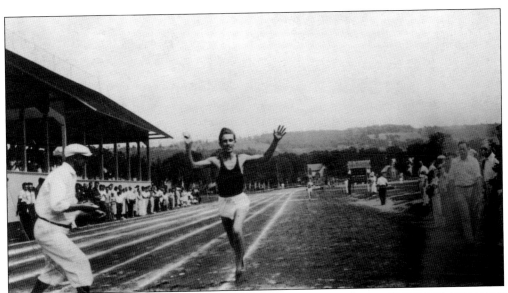

District sports events were highly anticipated by CCC members and the general public. One such event was the Fourth District sports championship held in Warsaw, New York, in October 1935. Over 200 CCC members from area camps competed in softball, baseball, boxing, and track. Roy Gath attended the event with other members of the Big Bend Camp and took this photograph of a runner crossing the finish line. (NHS.)

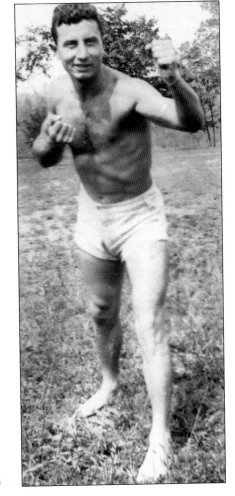

Camps had their own field days. Although less formal, they still provided competition and fun. The Lower Falls Camp held one on Decoration Day 1940 that featured barracks competing in regular track-and-field events along with a sack race, pie-eating contest, shoe race, tug of war, and a wheelbarrow race. This member of the Big Bend Camp may be training for his own field day. (NHS.)

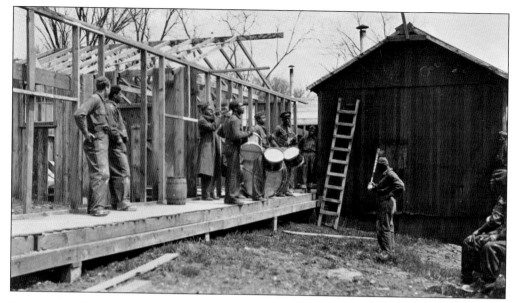

Dances were also popular. Camps often had their own bands, such as this one believed to belong to the black company at Gibsonville (above). Most dances were held in nearby dance halls or schools. Big Bend Camp held a dance at the nearby Nunda High School on April 27, 1934. The *Nunda News* announced: "music will be furnished by Lou Foote and his 10 Radio Artists, featuring Bill Best, direct from Duke Ellington's Band, and Vearnie Smith, NBC's smallest musician." There would also be a free lunch, a floor show, and three boxing bouts. Camp trucks often transported camp members to nearby towns, since cars were not allowed in the camp (below). One local farmwife made a few dollars a week by letting enrollees from the St. Helena Camp keep their cars in the family orchard. (Both, LSP.)

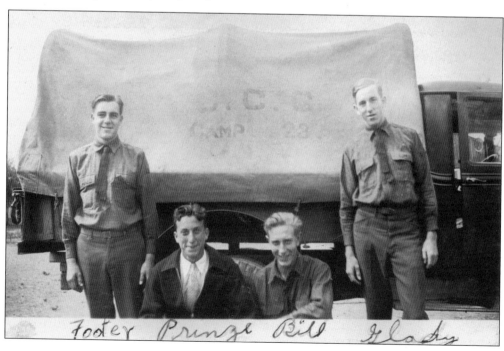

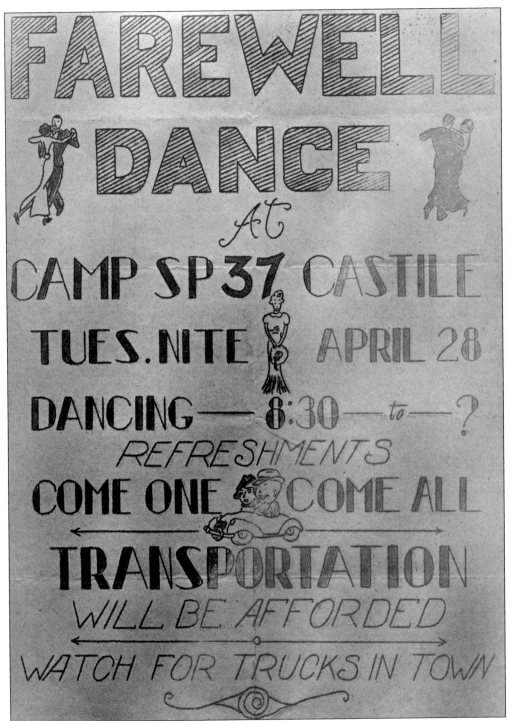

Some dances were held right in the camps. The enrollees of the St. Helena Camp printed and hung this poster advertising St. Helena Camp's farewell dance on April 28, 1936, a few days before the camp closed. Note that the CCC trucks would be sent into the neighboring towns to pick up civilians who wanted to attend. Ladies, of course, were free. (LSP.)

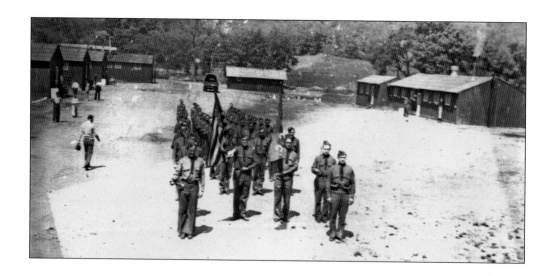

Sporting events and dances were not the only time that the Letchworth Camps and local communities came together. Enrollees often participated in area activities. Above, the men of Company 228 practice marching behind their barracks at the Big Bend Camp. Below, enrollees took pride in participating in local parades, such as the one held in Warsaw in July 1934. The float behind the marchers is the same one seen on page 2. According to newspaper accounts, members of the Big Bend Camp also participated in a Boy Scout "camporee" that same year. Camps also contributed an estimated $5,000 per month into the local economies through the purchase of supplies, employment of LEMs, and money spent by enrollees in town. (Both, NHS.)

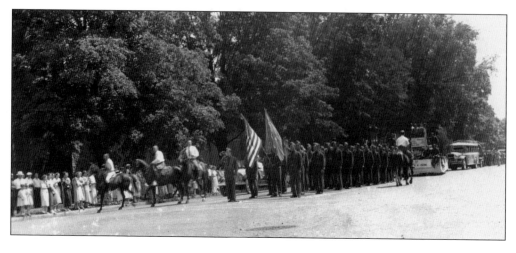

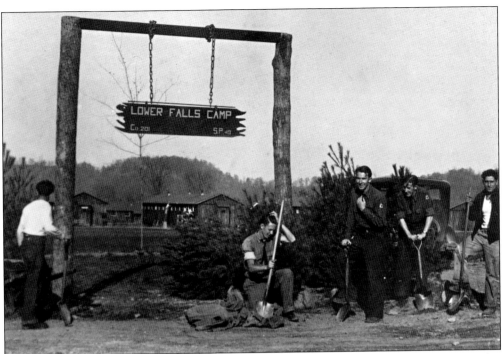

Members of Company 201 plant trees to spruce up the entrance to the Lower Falls Camp in this undated photograph (above). All the Letchworth Camps hosted special events that promoted the CCC program and helped to instill camp pride. The Gibsonville Camp, for example, celebrated its third anniversary in October 1936 with a party, which the *Nunda News* said would "be one of the most elaborate ever staged in a CCC Camp." A banquet, speeches, a dance, and the play *Ten Nights in a Barroom* brought many visitors. Plays were very popular in the Letchworth Camps (below). Each boasted a stage, like this one in the St. Helena recreation hall. Note the elaborate curtain, complete with the camp number. Sometimes traveling theater groups performed, but often a camp's dramatic club put on the plays. (Both, LSP.)

Female visitors were especially welcome. Roy Gath did not identify this couple but left no doubt that romance was involved. *Your CCC, A Handbook for Enrollees* states that "CCC men naturally become acquainted with young women in (nearby) communities . . . If you are the type of man who values self respect . . . you will probably exercise the same trait of character in your relationship with young women while you are in camp." (NHS.)

St. Helena Camp was the scene of a CCC wedding in December 1936. When Ernest Wise of Avoca, New York, a Company 264 veteran, proposed to Virginia Beattie of Canisteo, New York, his former captain and camp mates invited the couple to marry at the camp. An AP photographer captured the newlyweds walking through an arch of shovels. The photograph ran in the January 4, 1937, issue of *Life* magazine. (Davis family.)

An enrollee demonstrates some of his newly learned quarrying skills. Education was an important part of CCC life and extended beyond what a member learned on his work assignment. Each camp had an education advisor who worked under the camp commander to develop and implement a full educational program. One of the best was "Gibsonville University," which offered 44 classes taught by 29 instructors in 1936. (NHS.)

Classes were usually held one evening a week. Gibsonville students could choose among academic subjects such as American history, practical law, public speaking, arithmetic, and music appreciation. As in most camps, half the classes were vocational, ranging from job-seeking skills to training in areas such as welding, automobile mechanics, and surveying. These two certificates were earned by Dominic Tiano at the Lower Falls Camp in 1941. (LSP.)

Ivan Shute (center) relaxes in the Lower Falls Camp with two of his friends (above). Like many of his CCC buddies, Ivan had not finished high school. He would be able to continue his academic education in the camp through offerings on the elementary, high school, and even college levels. Nationally, 35,000 enrollees were taught to read and write, more than a thousand earned high school diplomas, and 39 received college degrees. Two members of the Gibsonville Camp practice their typing and writing skills (below). In February 1935, the *Gibsonville Howler* reported that "twenty six men are enrolled in Camp 40's typing class . . . Each man pays .50 a month toward rental of the typewriter on which he receives instruction." (Above, NHS; below, LSP.)

These enrollees might be getting ready for a CCC field trip or heading to a local school for an evening class. In 1941, Lower Falls enrollees were trucked to the Nunda High School for evening classes taught by faculty members. That same year, Syracuse University offered 37 different correspondence courses to enrollees. Local schools, colleges, and libraries often helped with camp libraries and classroom equipment, even providing instructors. (LSP.)

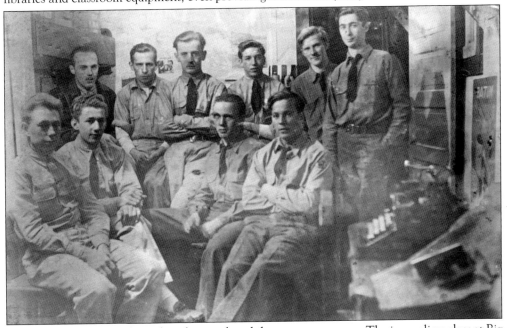

Each camp had a journalism class that produced the camp newspaper. The journalism class at Big Bend Camp was taught in 1935 by the editor of the local *Nunda News*, Walter B. Sanders. This photograph is believed to be of the Lower Falls Camp class that produced the *Genesee Gazette*. The other local camp newspapers included Big Bend's *23 Skiddoo*, the *Gibsonville Howler*, and St. Helena's *Spirit of '76*. (LSP.)

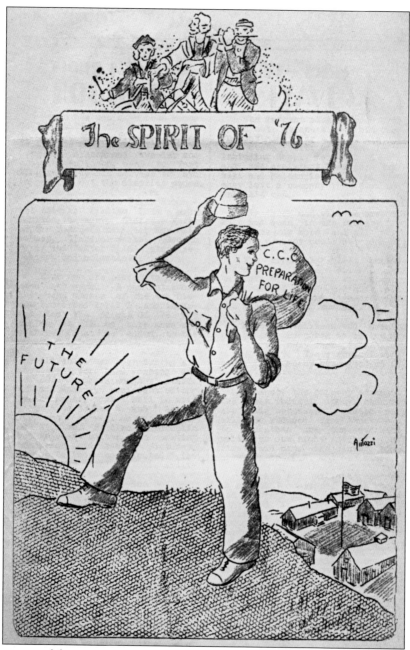

Surviving issues of the camp newspapers provide a wonderful glimpse into the CCC experience in Letchworth Park. They were usually mimeographed and generally six to eight pages long. The weekly newspapers included camp news and announcements, a column from the camp's skipper, and lots of humorous gossip about camp members. The *Genesee Gazette* titled its gossip column The March of Slime, which spent most of its time discussing the latest romances between enrollees and local girls. Occasionally, it reprinted information from *Happy Days*, the national CCC newspaper. Cover art, illustrations, and the frequent cartoons were all done by enrollees. This cover of the St. Helena's *Spirit of '76* reflects the belief shared by most members that their time in the CCC would lead to a bright future. (LSP.)

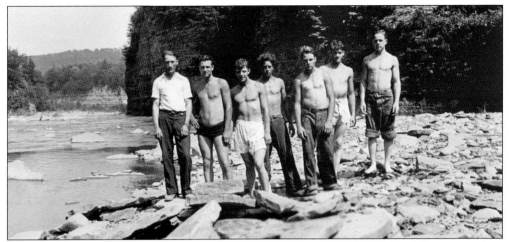

The park itself played a role in CCC camp life. Enrollees took advantage of the surrounding parklands in many ways. Men from the nearby Lower Falls Camp visits their favorite swimming hole (above). The area near the Lower Falls was a favorite swimming place at that time, but the park no longer allows swimming in the river. The St. Helena Camp created a toboggan slide in back of the recreation hall, visible at the top of the bank (below). When sprayed with water and allowed to freeze, the steep run became even more exciting. (Both, LSP.)

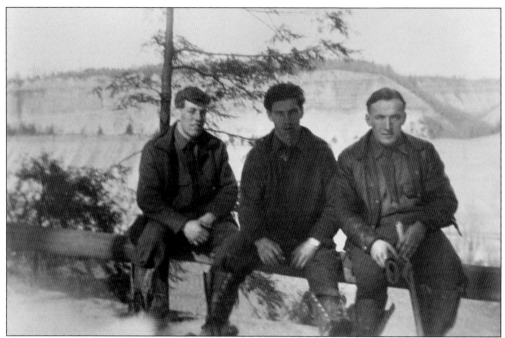

Hiking was also a favorite activity in all the camps. Three members of the Gibsonville Camp rest on a railing near in the Highbanks area of the northern park. Camp newspapers often included stories about the geology and history of Letchworth Park, which made the hikes more interesting. (LSP.)

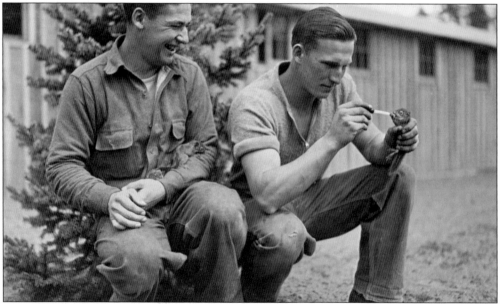

Although many of the enrollees were from cities and large towns, life in the park encouraged an appreciation for nature. They learned to identify trees, wild plants, and the difference between milk snakes and rattlesnakes. Orphaned wildlife sometimes became camp mascots. These two young men are feeding a baby squirrel with an eye dropper at the Gibsonville Camp. Pet raccoons could be found in most of the camps. (LSP.)

One of the most remembered of the Letchworth Camps' mascots was Dixie the deer. In this undated photograph from the Lower Falls Camp, Dixie is being tended to by one of the Company 201 enrollees. Dixie had her own barracks, an enclosure built of chicken wire and lumber from the park sawmill. Dixie's favorite companion was a small white cat. (LSP.)

Nature, of course, had its challenges. In 1935, enlistees line up on a cold winter day at what is probably the Big Bend Camp. Work was sometimes postponed on the worst weather days, but members still had to face the sweltering days of summer and the bitterest days of winter. (NHS.)

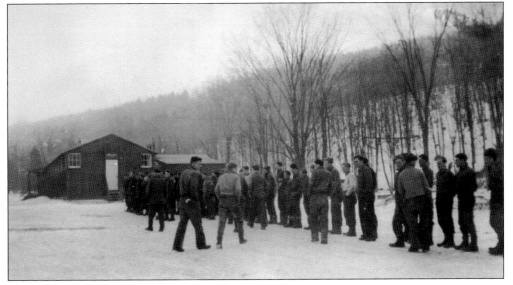

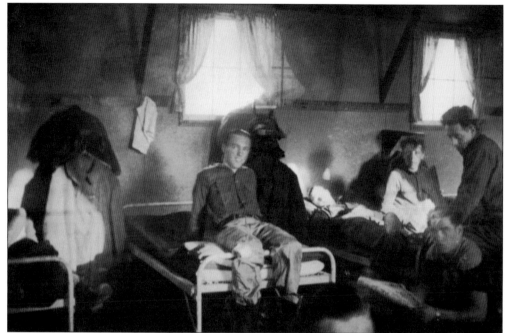

By the time the enrollees who lived in the Letchworth CCC camps such as Big Bend Camp (above) and the Lower Falls Camp (below) left the park, they probably agreed with *Your CCC, A Handbook for Enrollees* that "CCC camp life is a healthful one. It offers many opportunities for self improvement, physically, mentally and vocationally. Boys who 'can take it' will get much out of the CCC. They well may be proud of belonging to such an organization." As proud as they may have been to have successfully adapted to life in the CCC, they would have been even more proud of the work they and their CCC buddies accomplished for the park and neighboring communities. (Above NHS; below, LSP.)

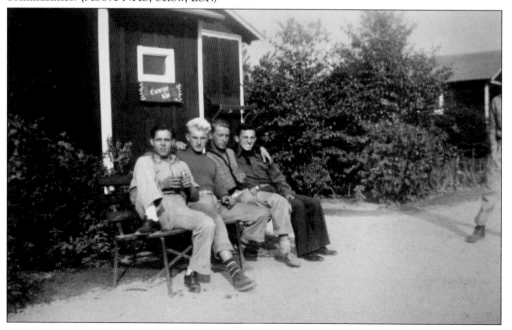

*Four*

# THE CCC AT WORK

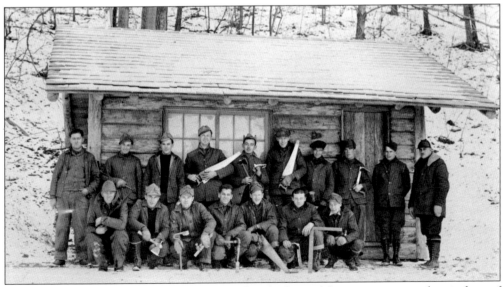

The CCC's "We can take it!" motto is reflected in the faces of the young men standing in front of a newly built cabin on the east side of Letchworth Park. Although many enrollees arrived unskilled and unused to hard labor, they advanced the development of Letchworth Park by decades. The quantity, quality, and variety of the projects they completed was truly remarkable. (LSP.)

# DEPARTMENT OF THE INTERIOR
## NATIONAL PARK SERVICE
### AND
### STATE OF NEW YORK
### GENESEE STATE PARK COMMISSION
#### COOPERATING

**BRANCH OF PLANNING**                    **STATE PARK DIVISION**

## LETCHWORTH STATE PARK
### NEW YORK STATE PARK #37

### BASE MAP SECTION 2

0      440      880              1760

| DRAWN BY F. W. SHORT | DATE FEB. 18, 1936. | SYMBOL 2-NY-37 | NUMBER SPNY LET 9014-2-3 |
|---|---|---|---|
| CAMP SUPERINTENDENT | | RECOMMENDED BY INSPECTOR | |
| PARK AUTHORITY | | APPROVED BY REGIONAL OFFICER | |

FILE: L—1—3
(SHEET 2 OF 3)

CCC work fell to the civilian side of the program. On the national level, two cabinet departments, Agriculture and Interior, oversaw the process of selecting, planning, and carrying out the projects. This label from an official 1937 planning map illustrates the various levels of administration (above). All of the Letchworth Camps, along with those situated in state parks, fell under the State Park Division of the Department of the Interior's National Park Service. Lower Falls Camp project superintendent Thomas C. Hance (left) checks a data point along a park road with foreman "Pops" Rosa (below). Each camp had (or occasionally shared) a project superintendent who was responsible for all aspects of what was called the technical services. Hance later worked in the park's engineering department for many years, as did Fred W. Short, who drew the map. (Both, LSP.)

This image, labeled "D.I. Office," was taken in the Lower Falls Camp. Once the home of local farmer Harvey Lee, the building became the civilian equivalent of the camp headquarters building. It housed the offices of the project superintendent and the other technical services personnel, which could include a forester, engineers, and landscape architects. The "D.I." stands for the Department of the Interior. (LSP.)

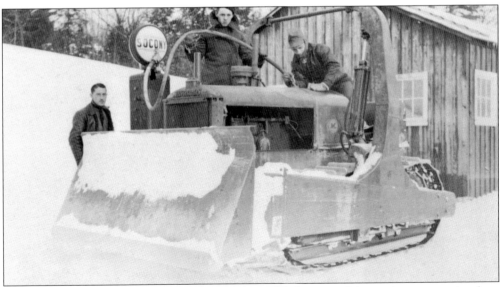

The camp superintendent and his staff were responsible for most of the equipment, ranging from shovels to heavy machinery. This bulldozer belonged to the St. Helena Camp. Other equipment—such as power shovels, compressors, rock drills, graders, jackhammers, and concrete mixers—was purchased or rented. Some trucks, horse teams, and small equipment were borrowed as needed from the park. The gasoline contract price was .079¢ per gallon in 1935. (LSP.)

The park sawmill was also available for use by the camps. Since the chestnut blight had killed many trees, CCC crews harvested this wood for construction projects in the park. The park sawmill, shown here around 1935, was enlarged during the CCC years. It is still in operation, turning salvaged timber into lumber for park projects. (LSP.)

Parklands also provided the stone and gravel that would be needed on many projects. Several gravel pits and stone quarries were available in the park. The oldest stone quarry may have been this one on the south edge of the park. Beyond the quarry, the old Pennsylvania Railroad trestle is visible, as is the highway bridge crossing the Genesee River at Portageville. (LSP.)

Some park personnel, such as engineers and maintenance men, did assist on some CCC projects. But each camp had two indispensable staff members, a mechanic and a blacksmith. St. Helena Camp's blacksmith, shown here, is unidentified, but records show that a C. Tracy Lewis from Perry, New York, once worked as the blacksmith at the Lower Falls Camp. (LSP.)

"Pop, one of the best foremen," wrote Robert Kirtland in his Lower Falls scrapbook. Camp superintendents were expected to hire foremen "who live in the vicinity of the camps, who are unemployed, who have had actual experience in the classes of work to be done and who are fitted to exercise wholesome leadership over junior enrollees." Local experienced men (LEMs) were essential to CCC projects. (LSP.)

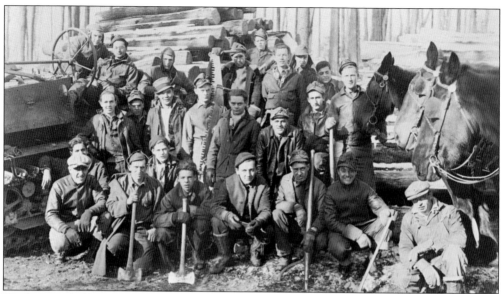

Work crews, led by foremen or assistant foremen, did the actual work. These crews were usually made up of 15 to 25 men and were often identified by their foreman such as Bob Fox's Crew or by their type of work as in the woods crew (above) and the quarry crew (below). Camp superintendents assigned enrollees to crews carefully. Big Bend project superintendent E.A. Heers writes in his September 1935 report: "In assigning men to these varied projects, some effort has been made to place them according to their own desires for experience which will be of later consequence. For instance, several men with a penchant for masonry have, through good supervision, become proficient in the cutting and laying of stone and have proved valuable in development of the park quarry, providing materials for the bridge and trail projects." (Both, LSP.)

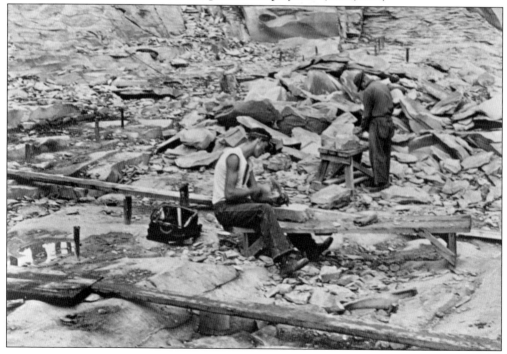

The Letchworth Camps had the personnel and equipment to carry out a wide variety of projects, but what determined what work was done? First, all CCC work had to fall into one of three categories: forest improvement and protection, soil conservation, or park development. The fall tree planting captured in this image from the park's archives certainly would be an acceptable project for the camps. (LSP.)

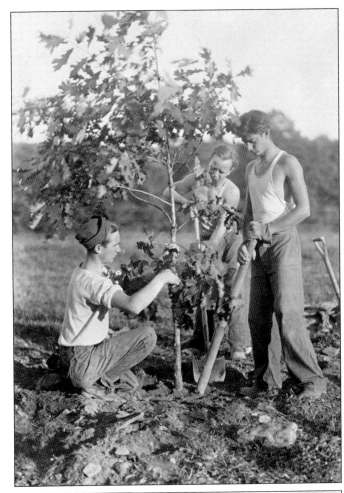

Second, park officials had already created development plans for the park and were well aware of the valley's conservation needs. These fell neatly into the CCC work categories so all that was needed was to prioritize them and apply for camps. It is no surprise that the first camp (below) was located in the undeveloped parklands on the east side of the Genesee River at Big Bend. (LSP.)

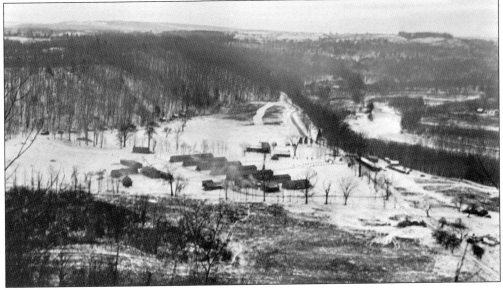

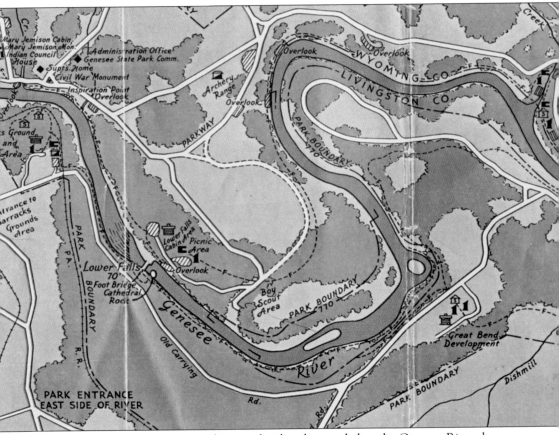

Officials felt the most pressing need was to develop the area below the Genesee River shown on this July 1935 map, which comprised the park's eastern lands. Before the CCC arrived, little had been done. Access was difficult, no facilities existed for park visitors, and the forests were in dire need of conservation work. When the Big Bend Camp was established in June 1933 at the Great Bend Development (indicated on this map), only an old narrow dirt road reached the campsite. The Old Carrying Road, the ancient portage route that had given the local township of Portage its name, was not much more than a path below the Lower Falls. The old Civil War barracks grounds were just an overgrown field. There was much work to be done if these lands were to enjoyed by the growing number of tourists.

Big Bend work crews were on the job shortly after the first tent was pitched. Over the next six months, an average of 146 enrollees headed out of camp each weekday, the rest remaining behind for camp projects and duties. Priority was given to improving road access to the camp. A power shovel is used to build the road into camp in this photograph from enrollee Roy Gath's album (above). Although heavy machinery was used when available, manpower was essential. A road crew works on the shoulder of the Old Carrying Road as the power shovel works in the distance (below). On the east side, the roads cost an average of $2,254 a mile, about $40,000 in today's dollars. (Above, NHS; below, LSP.)

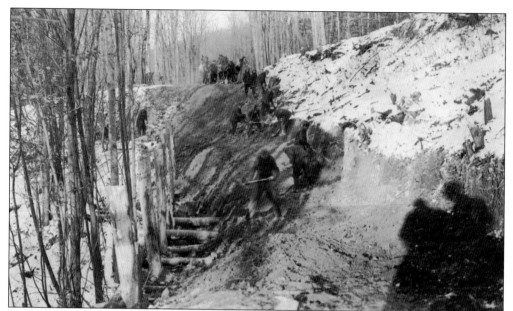

It was all shovels, strong backs, and horse teams when it came to opening the section of the Carrying Road shown here. A December 1933 report states that "a 3 mile strip of standard gravel road with 18 foot pavement is completed which involved the handling of 6,000 cubic yards of dirt, 3,000 yards of gravel . . . Another 3 mile strip of standard gravel road is nearing completion." (LSP.)

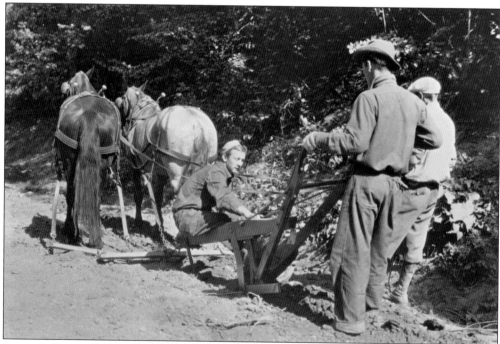

A team of horses helps to break the soil on the edge of one of the roads. One enrollee serves as ballast while another guides the plow. These horses might have belonged to the camp or were on loan from the park. When figuring cost estimates, each team was valued at $6.50 per day. Many enrollees had no experience with horses, but they learned quickly. (LSP.)

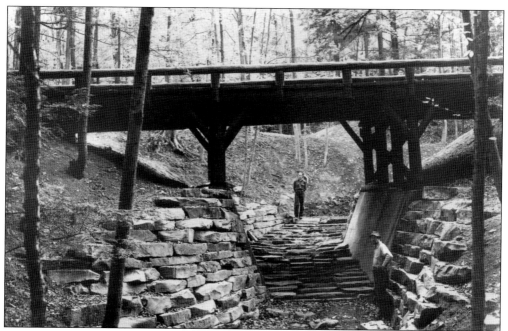

Road construction also demanded the installation of drainage pipes and tiles, catch basins, and bridges. This is one of the two log bridges constructed along the Carrying Road by the Big Bend Camp. Later, these log bridges were replaced with concrete and stone spans. (LSP.)

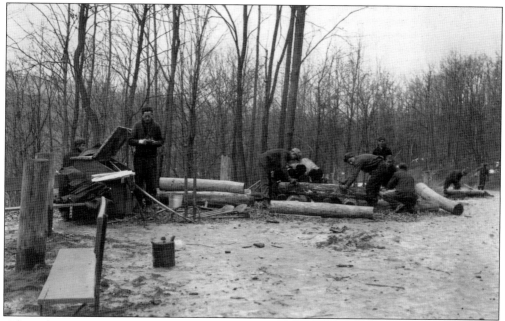

Where the Carrying Road came close to the gorge, railings were installed using the logs salvaged from the dead chestnut trees found nearby. The railings were 18 inches above grade and set on chestnut posts that were buried three feet down in the ground. Each post was coated with creosote. Crews also placed 45 telephone poles to bring electricity and telephone service to the camp. (LSP.)

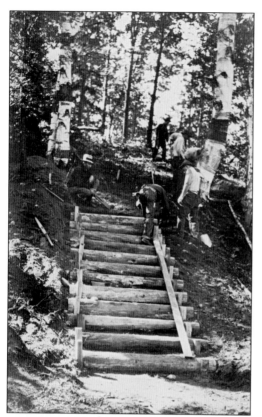

Almost four miles of foot trails were constructed in the first few months, with log or stone steps and footbridges as needed. The new trails were five feet wide with gentle grades suitable for the average park visitor. Here, a Big Bend crew works on a set of log steps somewhere on the east side of the park. According to official reports, the trails cost an average of 10¢ per foot. (LSP.)

Woods crews were assigned the job of forest improvement and conservation. The foremen on these crews were experienced local woodsmen who taught enrollees how to safely use the double-bitted axes and other equipment. Although mishandling of tools and falling objects were among the leading causes of injuries in CCC camps, only three minor injuries from saws or axes were reported at Big Bend during February 1934. (NHS.)

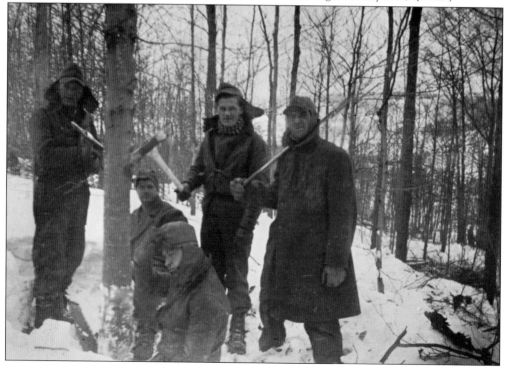

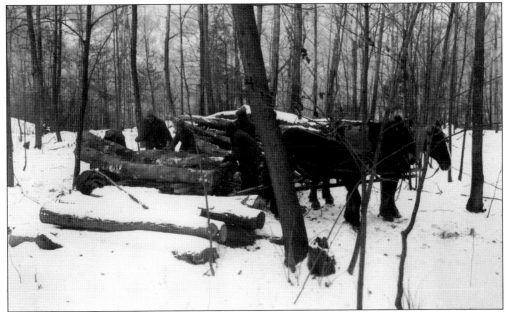

Enrollees load a sled with logs. During winter months, the emphasis was on forest improvement. Dead trees and thick brush were removed to reduce the threat of fire, the valuable timber saved for park use. Over the 1933–1934 winter, 125,000 feet of sawlogs and 1,500 cords of firewood were salvaged. Five hundred cords were donated to local agencies for distribution among the poor. (LSP.)

A small crew rests with the foreman as they work on other aspects of forest improvement. In a single two-month period in 1935, Big Bend enrollees planted over 5,000 trees and shrubs. Over six months, they also cleared 1,000 acres of 35,000 currant and gooseberry bushes, which were acting as host to the white pine blister rust. Eventually, the entire park was successfully cleared of this threat. (NHS.)

"Few residents of this section can vision what has taken place at the camp since its founding only a few months back," reported a local newspaper in December 1933. "Roads have been built and others widened . . . trails built in the woods, trees planted, dead wood cut and other forestry work carried on . . . making accessible to tourists and home folk a section of the Genesee not heretofore fit for motor travel." This is the view of the Big Bend Camp that tourists would have had when arriving along the improved Carrying Road (above). The park and CCC officials had more than just access in mind. Together, they laid the plans for facilities for the growing number of tourists. This picnic shelter, built within the camp, was to be part of the Great Bend Development Area (below). (Both, LSP.)

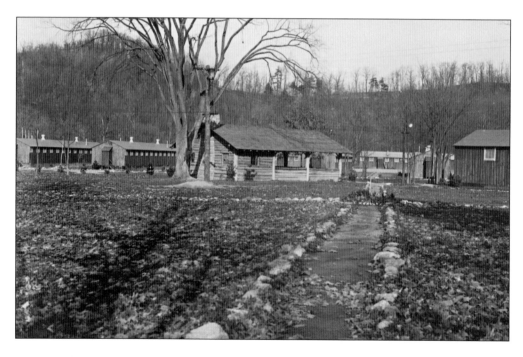

Over the next two years, the Big Bend Camp built cabins in both the Great Bend Development Area (Cabin Area E) and the Barracks Grounds (Cabin Area D). These cabins came in two sizes—the small style seen in the photograph above and the larger cabin below. These cabins were set on concrete piers and sided with log slabs. One of the enrollees stands in the doorway of one of the completed cabins probably located at the Great Bend Development Area. In addition to the picnic shelter, a comfort station and a combination shower and laundry building were later added to this area, as well as a water system. (Both, LSP.)

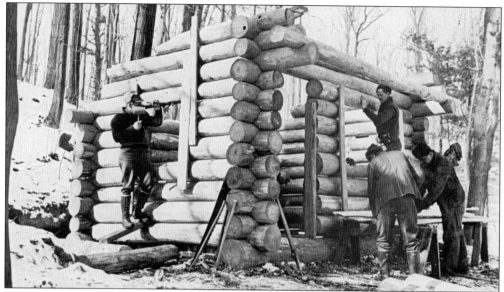

The Barracks Grounds (or Parade Grounds) received a lot of attention from the Big Bend Camp. A total of 10 cabins were constructed, including some with actual logs rather than just sided with log slabs. A shower and laundry building was also built and provided with water from a 5,000-gallon reservoir. (LSP.)

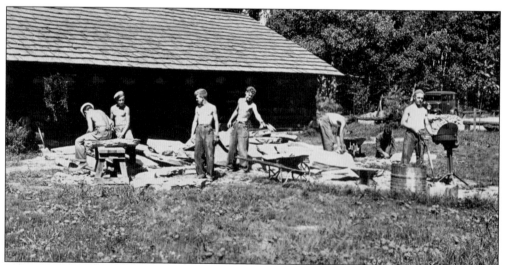

Enrollees work on stone brought from the park's quarry for the new shelter seen behind them. The 29-by-52-foot combination picnic shelter and comfort station was the centerpiece of the Barracks Grounds picnic area development. Made of chestnut timber, it was estimated to cost $655 to build. The comfort station was at the north end. The stone is for the shelter's flagstone floor. (LSP.)

Masons and their crews work on the beautiful stone tables on the hillside above the new shelter (above). When completed, the shelter and nearby tables, fireplaces, and drinking fountains (below) were instantly popular. In his July 1935 report, camp superintendent E.A. Heers wrote, "The summer influx of visitors still maintains a record pace with evidence of increasing interest in the developments on this hitherto-undeveloped side of the river gorge. The demand for overnight cabins has been such that eight of the ten [cabins] in the new Barracks Ground development have been equipped and rented by park authorities." The Barracks Grounds quickly became a favorite location for family reunions, group picnics, and the annual Soldiers' Picnics, formerly held at the Portage High Bridge. (Both, LSP.)

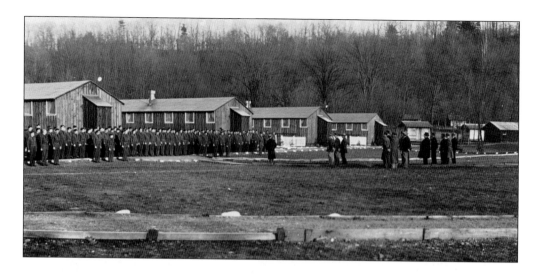

The successes of Big Bend Camp 23 did not go unnoticed. In March 1934, the camp was designated the best CCC camp out of the 160 camps in the 2nd Corps area. Col. Charles Morrow commended the camp officers, civilians, and enrollees, telling them, "You have made this place of God's beauty still more beautiful." The following year, CCC director Robert Fechner visited and addressed the company, telling them that Big Bend Camp 23 was one of the outstanding camps in the entire country. Above, Fechner is the one in a black coat standing near the center and to the right of the enrollees, and he also visited the Gibsonville and St. Helena Camps that had opened on the west side of the river. Below, Fechner (center) poses with Col. Charles Morrow (far left) and other CCC officials. (Both, LSP.)

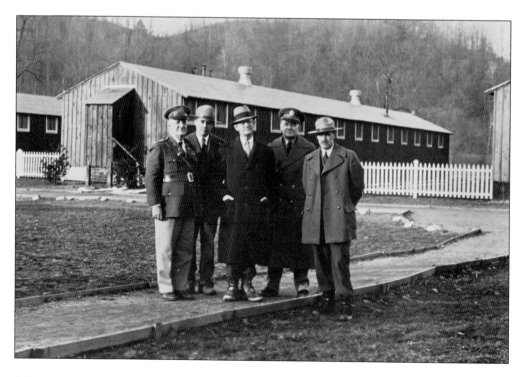

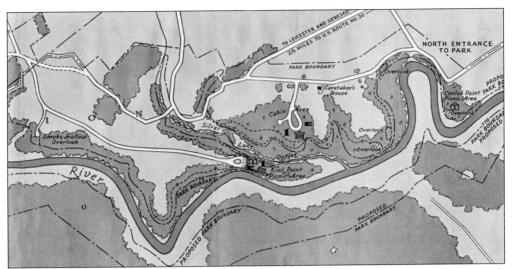

When the park began its northern expansion in the 1920s, the dream was to build a "Letchworth Boulevard" to Mount Morris, developing cabin, camping, and picnic areas along the way. The Gibsonville Camp was well placed to carry out these plans when it opened in the fall of 1933. It is located on this 1935 map just below the spot where the road crosses Silver Lake Outlet to the left of the word *silver*. North is to the right on this map.

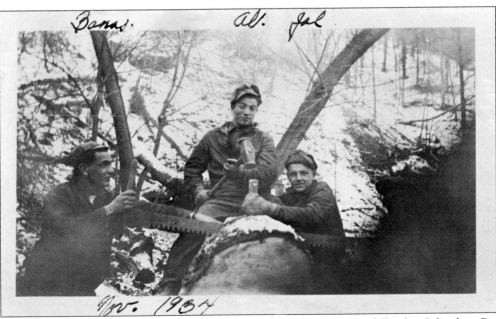

These enrollees work on freeing their two-man saw as they work on a fallen log. Like their Big Bend counterparts, Gibsonville crews spent a lot of time on forest improvement. During the camp's first winter, workers salvaged over 25,000 board feet of chestnut and other lumber as well as 1,200 cords of firewood. Crews removed currant and gooseberry bushes and cleared 300 acres of fire hazards. (LSP.)

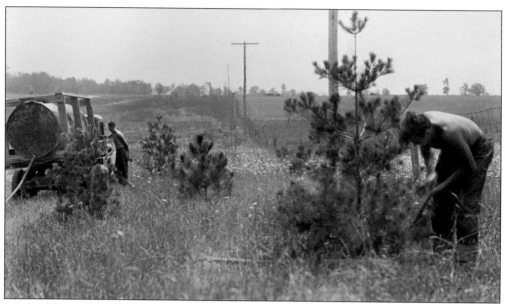

Much of the new lands of the park had been farmland when acquired by the State of New York. This meant that reforestation became a priority. By March 1936, the camp had planted some 70,000 red and white pine seedlings and transplanted over 10,000 native trees and shrubs. Here, enrollees from the Gibsonville Camp are watering some newly transplanted trees. (LSP.)

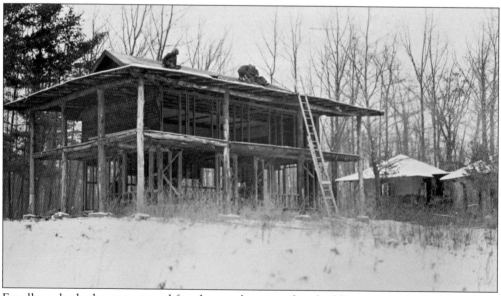

Enrollees also had to raze several farmhouses, barns, and outbuildings, some of which had been part of the old Gibsonville community. This cottage and outbuildings once stood at Conlon Point and were taken down in January 1935. (LSP.)

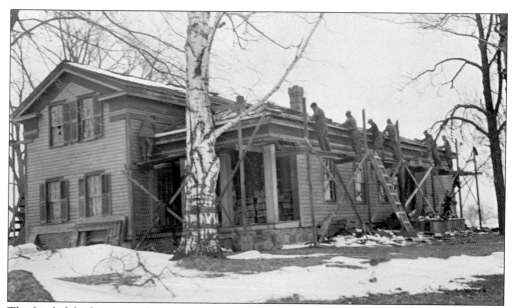

The Littledyke house, at the entrance to modern-day Highbanks camping area, was the only structure of the old Gibsonville community that was spared. Built in the early 1800s, the Greek Revival structure got its name from William and Hattie Littledyke, who purchased the home before 1902. Today, it is known as Maplewood and can be rented by visitors. In this photograph, CCC crews are making repairs on the house. (LSP.)

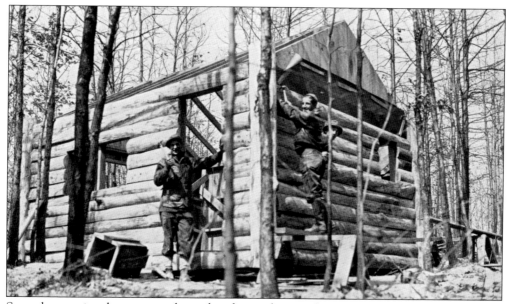

Several recreational areas were planned in the northern park. First, a new cabin area was cleared north of the camp. By the spring of 1934, the first six slab-sided cabins (pictured) were completed. Eventually, 18 cabins, a comfort station, stone fireplaces, drinking fountains, and a shower and laundry building would be built in what is now known as Cabin Area C. (LSP.)

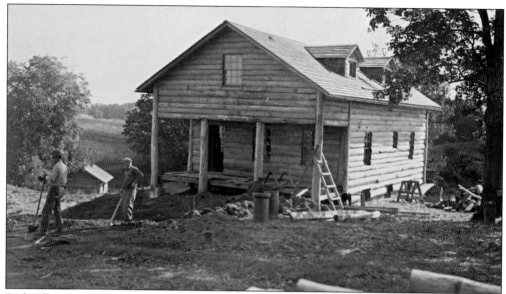

Park officials Charles Van Arsdale and Wolcott Humphrey worked with Gibsonville Camp project superintendent Don Kessler in early May 1935, to select the spot where a new large cabin would be built. The structure, consisting of five rooms and a two-car garage in the basement, would become the cabin area caretaker's residence. The house, shown here under construction in October 1935, was completed early the next year. (LSP.)

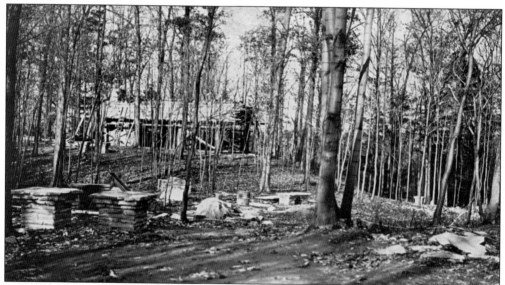

New picnic areas were developed at Kisil and Conlon Points. Kisil Point, shown under construction, included a 24-by-40-foot picnic shelter, 12 stone tables, stone fireplaces, and a comfort station. The Conlon Point area was located on what was then the northern edge of parkland, overlooking the Hogsback area. Both Kisil and Conlon Points were named for the family who formerly owned the property. (LSP.)

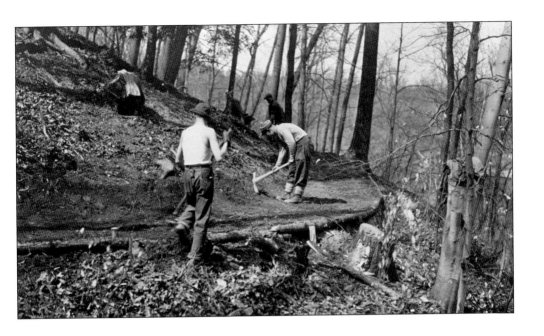

To connect these new recreational areas, the camp also built over five miles of foot and bridle trails. Many of the trails required cribbing (reinforcement with logs) on steep banks and footbridges across the creeks. The crew above is working on a foot trail. Logs have been stacked in place on the slope to hold the packed soil, and enrollees are cutting back the bank to widen the trail. The Adirondack-type shelter below was built for the use of hikers. This shelter, shown as it neared completion in March 1936, still stands today. At the time of this writing, plans are underway to restore the structure. (Both, LSP.)

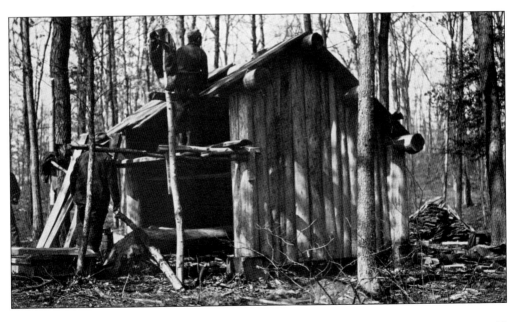

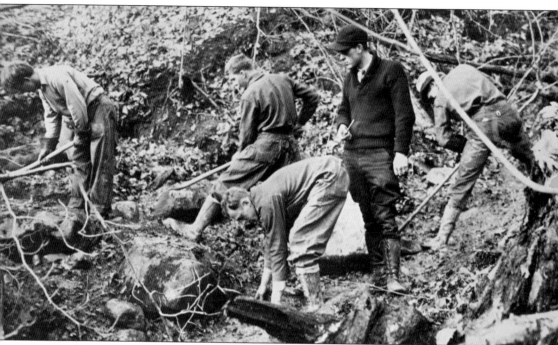

The new facilities also needed water. The camp installed a pump house and two miles of pipe to link to the waterline between Silver Lake and Mount Morris. Whether it was digging water lines, foundations, or new trails, Gibsonville enrollees such as those above showed an unusual willingness to man a shovel. This is explained in a December 1, 1933, *Nunda News* article, "Forest Army Shows Zeal in Digging after 'Gold' Story." It seems a local resident had visited the camp and told the enrollees that his great-grandfather had buried a chest of coins and valuables in the area before he went off to the War of 1812. The man had never returned, and generations had searched in vain for the treasure. "Real or legendary," the article goes on to say, "the story kindled the imaginations of the forest army and when orders went out from officers to dig . . . their commands were met with welcome . . . the boys go at it with a vim and enthusiasm that is truly astounding." No treasure was found. (LSP.)

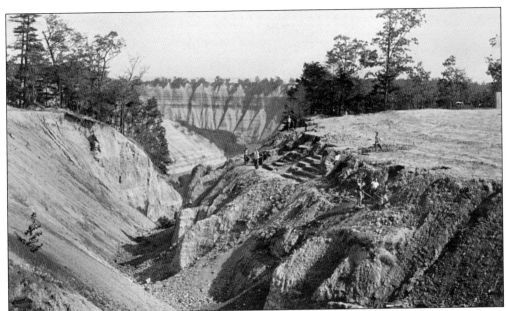

Erosion control was another important part of the CCC's mission in Letchworth Park. Cribbing and planting trees and shrubs were common practices along trails and roadways. The largest CCC erosion project in the park was the Crapsey slide work. The gully located near the Hogsback was 1,000 feet long and 90 feet deep at one end, and it was growing by about 50 feet each year. To stop the erosion, a 500-foot concrete culvert was installed, the upper end of the gully filled, and remaining banks sloped with soil and planted with trees and shrubs. Above, enrollees work on the banks of the gully. At right, work is underway on the large culvert. (Both, LSP.)

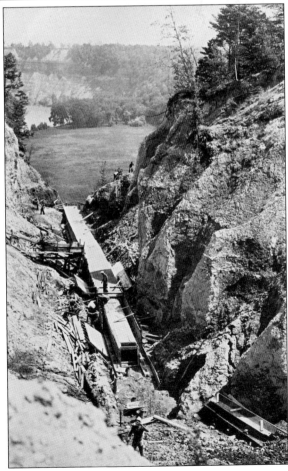

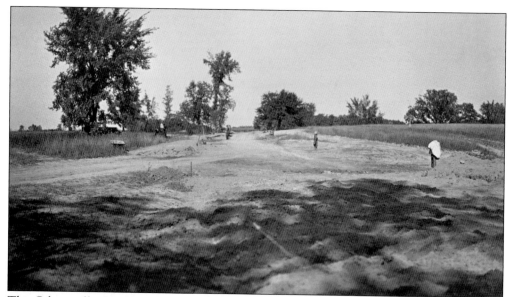

The Gibsonville Camp's other important project was work on the northern section of the Letchworth parkway and the roadways to Kisil Point and the new cabin area. This work included grading the roadbed, installing culverts, and grading, sodding, and seeding the slopes along the roads. This view along the developing parkway was taken in September 1934. Forests started by the CCC now cover these once-open fields. (LSP.)

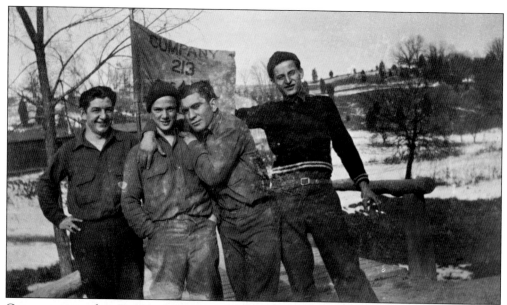

Camp superintendent Don Kessler was quite proud of the Gibsonville Camp's accomplishments. In a special narrative report submitted in March 1936, he concludes that "it may be easily seen that a considerable amount of very valuable work has been accomplished in this section of Letchworth Park." He attributed the camp's success to the hard work and the spirit of the enrollees, such as these unidentified men. (LSP.)

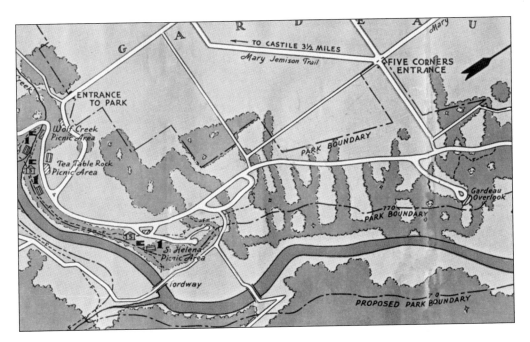

Letchworth's third camp, located just above the name St. Helena on this 1935 map, was responsible for projects in the middle section of the park. The camp's application identified over 32 work projects of the camp. In the spring of 1936, after two years of operation, acting project superintendent E.A. Heers reported that the "accomplishments of NYSP Camp 37 . . . have been many and varied, yet coordinated with similar accomplishments of NYSP Camp 5 and 49 to the south and 17 to the north. This has meant good progress on the general program of development." One of these accomplishments was the work at the St. Helena picnic area near the camp. This new area, like the park's other new picnic spots, would include stone tables and fountains, a comfort station, and a picnic shelter, shown under construction here. (Below, LSP.)

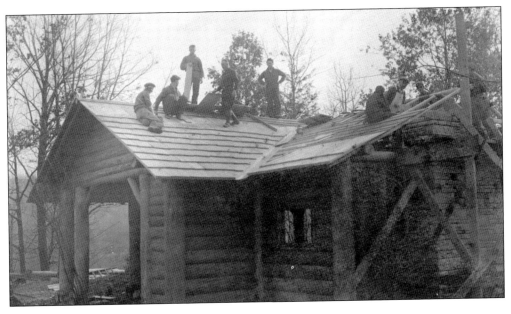

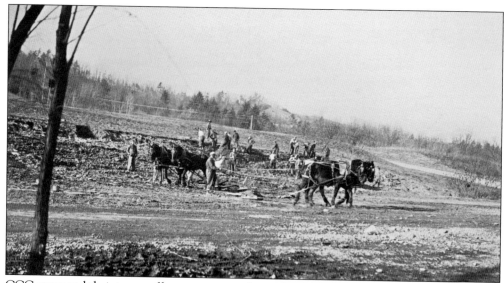

CCC crews and their teams of horses excavate the parking area at St. Helena in November 1934. The parking lot would eventually hold 50 cars. Enrollees also razed the last remaining buildings of the once thriving community of St. Helena in the river valley below. (LSP.)

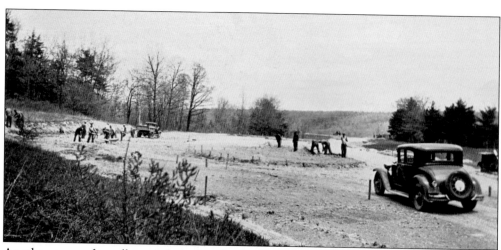

Another group of enrollees works by hand to build the Gardeau overlook north of St. Helena. Once completed, the overlook would provide a spectacular view of the Gardeau Flats, once the home of Mary Jemison, the famous "White Woman of the Genesee." (LSP.)

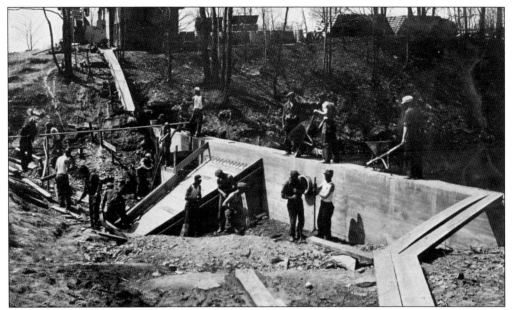

Not far from the new Gardeau Overlook was this recreational dam or reservoir just west of the expanding roadway. The St. Helena Camp also completed a 100,000-gallon reservoir on the hill above the Glen Iris, a project that had been started by the Big Bend Camp. Although the reservoir still exists, only a few traces of the dam remain today. (LSP.)

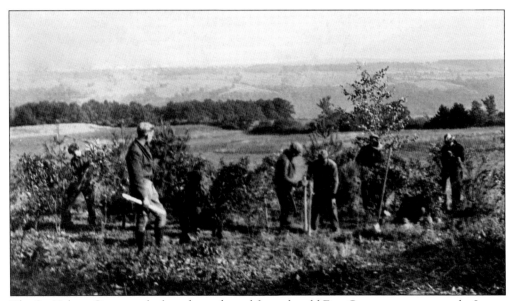

The St. Helena Camp worked on the park road from the old Five Corners entrance to the Lower Falls Road. Much of it was landscaping work along the roadsides, such as adding topsoil, seeding, sodding, or tree planting, as shown here near the Five Corners. Note how open much of the new parklands were at the time. The Five Corners entrance is no longer used. (LSP.)

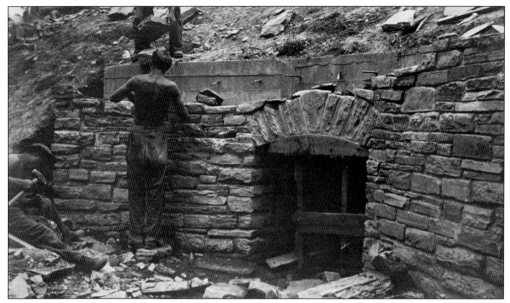

The camp could only claim the completion of two miles of the parkway in two years, but the work had entailed "considerable cement and stone work on culverts, drains, catch basins and headwalls." These enrollees from St. Helena are laying a beautiful stone facing on a culvert along one of the park roads. (LSP.)

Stone was also used on the several miles of trails built by the camp. Stone steps and small bridges such as this one, built by the St. Helena Camp, can still be found in the park today. (LSP.)

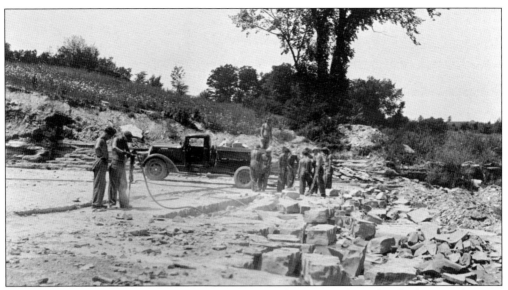

Most of the stonework in this area came from a second quarry in the park, which a crew from St. Helena manned between 1934 and 1936. The quarry, shown here, was north of the camp. Several gravel pits were also opened on both sides of the river to provide material for road construction and other projects. (LSP.)

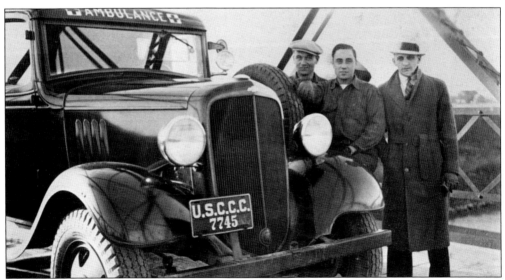

Just as forest work had its dangers, so did the road- and stonework. This photograph comes from a scrapbook of a St. Helena enrollee. It appears that St. Helena may have had its own camp ambulance, shown here with crew members "Chuck, Fiore, and Casey." The central location of the camp would have allowed the ambulance to be on call for the other Letchworth Camps. (LSP.)

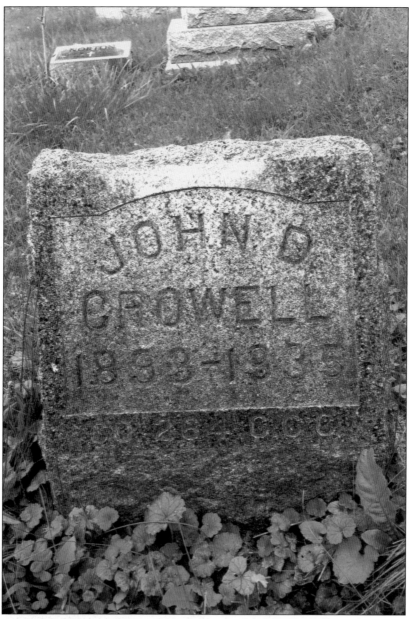

Fatalities were rare, but did happen. Assistant leader John D. Crowell was home on leave in Wyoming, New York, on March 17, 1935, when a violent storm brought down some power lines in town. Neighbors went to Crowell for help. As his posthumous CCC citation reads, "He thought only of the safety of the little children attending Sunday school during a windstorm which hurled a twisting crackling high voltage line across the sidewalk in front of the Church." Crowell was electrocuted as he attempted to move the wires. His CCC buddies were the pallbearers, and all his camp attended his funeral. Crowell's stone has "C.C.C. Company 264" carved on it. Another fatality was Peter Willowby of New York City. Willowby had disappeared from camp in early April 1936. He was listed as AWOL, but in July of that year, a local fisherman found his body in the river gorge. It was believed that he had tried to cross the river on the spring ice but had broken through and drowned. (Photograph by Clair and Joseph Breslin.)

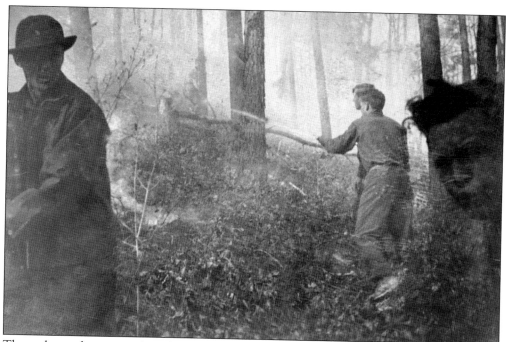

The park was the primary beneficiary of the work of the CCC, but nearby communities also benefited from the camps. Originally, all CCC work had to be done on public lands, but it was decided that the enrollees could be called when fires, floods, and other disasters struck. So, CCC men often became first responders to emergencies in the area. Hazy with smoke and marred by the developer's fingerprint, the action photograph above, by Roy Gath, captures Big Bend camp enrollees as they fight fire on what may be the Rattlesnake Hill area of southern Livingston County. At right, Letchworth enrollees dig a fire break during a peat fire near Medina, Orleans County, in August 1934. They also spent several days fighting a similar fire in Alabama, Genesee County. (Above, NHS; right, LSP.)

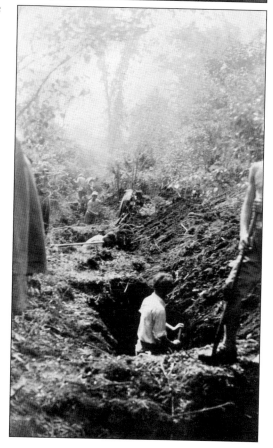

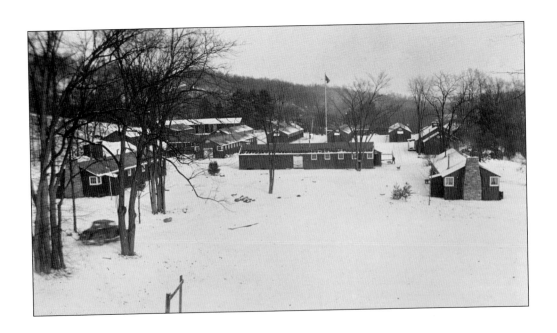

The Letchworth Camps, such as St. Helena above, were also on call for snowstorms. The first three months of 1936 were particularity bad in the Genesee Valley. Bitter cold, heavy snow, and high winds along with a vicious sleet storm struck the area. In January, a small group of enrollees from Gibsonville braved the elements to take food and fuel to a local farmhouse "whose people were on relief and without food." Below, enrollees from St. Helena dig out a stranded motorist on a local road. During January and February, according to a Camp 37 report, "motorists hauled from the drifts during howling weather and highway officials were warm in expressing thanks and appreciation." (Both, LSP.)

This portion of a CCC planning map shows the Lower Falls section of the park in 1937. The Lower Falls Camp SP 49, located in the lower center of the image, opened in July 1935. With camps operating to the east and north, the new camp was perfectly situated to carry out development projects in some of the original parklands. The Trailer Camp is today's Group Camping. (LSP.)

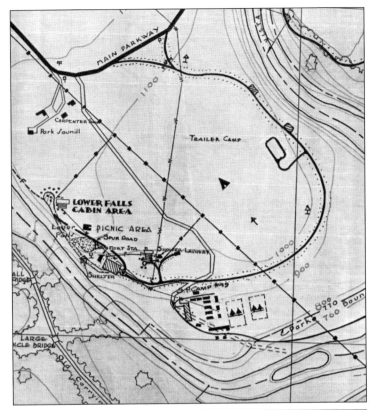

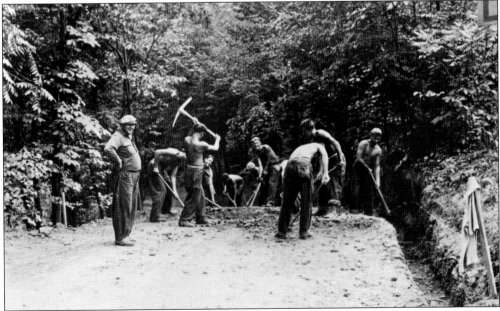

A Lower Falls crew grades the road to its new camp under the watchful eye of a foreman in August 1935. This was the beginning of a three-year project to build a new road from the main parkway to the Lower Falls area, including drainage work and several scenic overlooks. The new road is visible on the map at the top of the page and is still in use today. (LSP.)

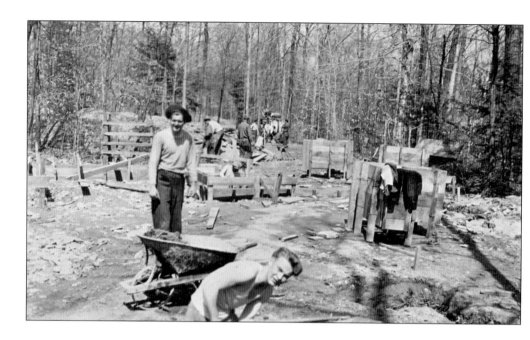

Tent camping had opened in the Lower Falls area in 1923. A small cabin area was later added, but a local newspaper complained in January 1934 that "cabin facilities have been very limited." So, one of the projects for the new camp was to expand the cabin facilities near the Lower Falls. Above, enrollees prepare the site for a new cabin area north of the original group of cabins. New cabins were added, and according to a March 31, 1936, report, "congestion in the [cabin] area was relieved by moving crowded cabins" to the new area. Below, two teams are providing the necessary horsepower to move one of the cabins. Trucks were also used. A close look at the map on the previous page shows the two cabin areas, with their locations indicated by little cabin symbols. (Both, LSP.)

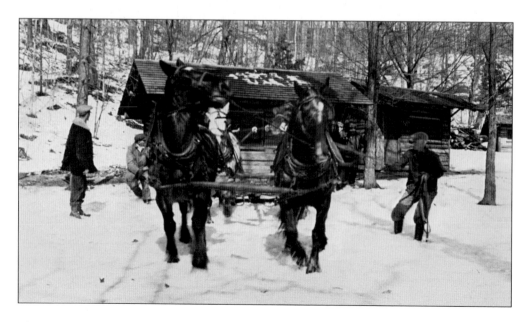

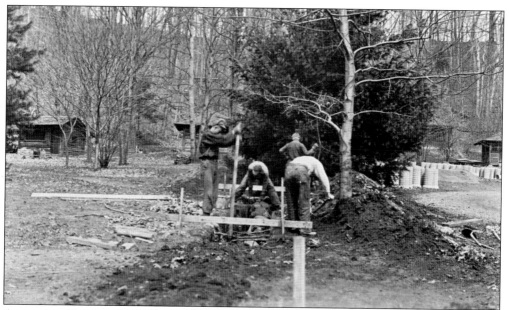

A crew installs part of a 900-lineal-foot drainage line in an attempt to improve drainage in the older cabin area. By 1948, this area was called Cabin Area A. The new cabin area was designated Area B. Eventually, the old Cabin Area A was abandoned and rebuilt at its present location. The CCC-era Cabin Area B is still in use today. (LSP.)

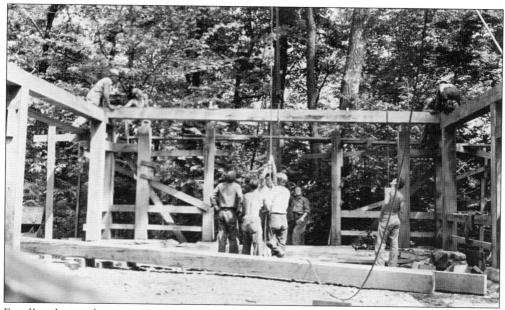

Enrollees hoist a beam in place in the new Lower Falls Shelter. The shelter would have a stone fireplace and flagstone floor. An alcove with a stone fireplace is to the left. Comfort stations, along with stone tables and fireplaces, would be added to the picnic grounds nearby. The last CCC reunion would be held in this shelter nearly 80 years later. (LSP.)

In August 1936, a staff writer for the Lower Falls Camp newspaper wrote that "the Letchworth Tree and Shrub Nursery, comprising a project somewhat different from the usual type under State Park Emergency Work, is in advanced stage of development at this Lower Falls Camp . . . It is proposed to grow in this nursery only such native trees as will be used in landscaping developments within the territory of the Genesee Park Commission." It was reported in the spring of 1938 that about 30,000 "plants and nut trees" were ready for transplanting. Above, members of the nursery crew are setting out seedlings in the new nursery. Below, enrollees are setting out pine trees started in the park. Nationwide, the CCC planted an estimated 3 billion trees. The Lower Falls nursery is shown on the map on page 103 just right of the camp. (Both, LSP.)

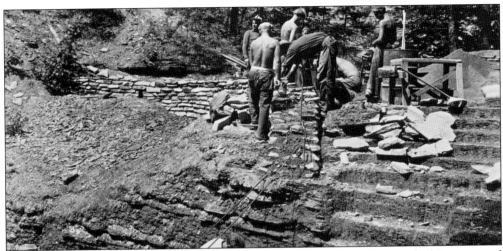

The Lower Falls Camp lasted longer than any other Letchworth camp, a total of six years and three months. During that time, the CCC constructed three reservoirs; built parking lots at the Wolf Creek, Tea Table, and Lower Falls areas; established five miles of ski trails; completed toboggan slides at St. Helena; and finished road projects near Five Corners, Kisil Point, and the Highbanks areas. The camp also improved the trails and picnic areas at Wolf Creek and Tea Table and built stone walls in several areas. Above, enrollees work on a stone wall near the Lower Falls. This was part of the Lower Falls footbridge project started by the Big Bend Camp in the narrow portion of the gorge below Lower Falls. An early postcard below shows the location of the future bridge. (Above, LSP.)

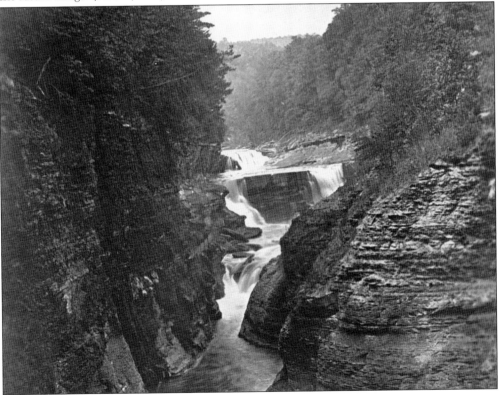

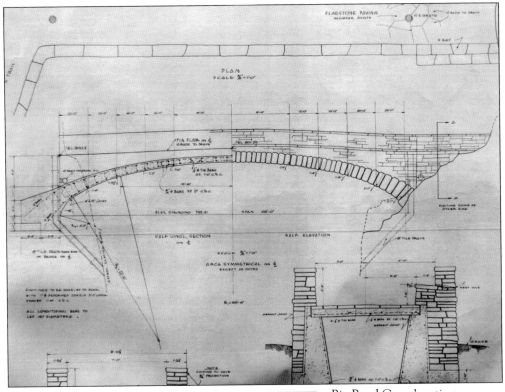

Big Bend Camp's acting project superintendent E.A. Heers called the project "the fulfillment of one of the foremost dreams . . . a day when opposite banks of the scenic gorge would be linked with a bridge in harmony with the surrounding wonders." Designed by the young architect Garrett V.S. Ryerson Jr., the stone span was projected to cost $695 (above). Construction started in the first months of 1934 (left). The flume was widened by blasting, and a footbridge was built to allow workers to begin work on the bridge foundations. High water, like that shown in Roy Gath's photograph, made the initial work difficult. A rock fall took out the temporary bridge and forced crews to scale back the eastern cliff. (Above, LSP; left, NHS.)

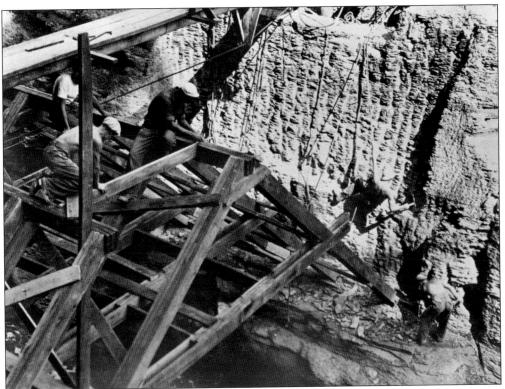

As work progressed, a timber form was built across the flume. Stone ledges were blasted and chiseled for the framing to rest on. In this image, an enrollee suspended on a rope works on preparing the cliff wall for the bridge's foundation as others work on the form high above the river. (LSP.)

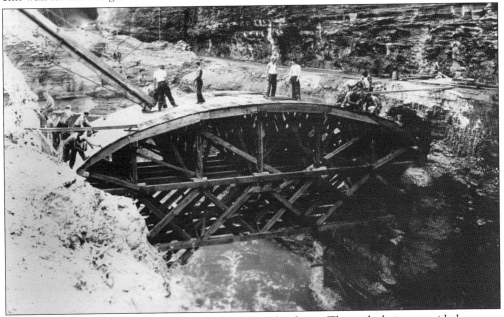

Once the form was finished, the bridge started to take shape. The arch design provided support and was anchored to the sides with rods that extended eight to nine feet into the rock. (LSP.)

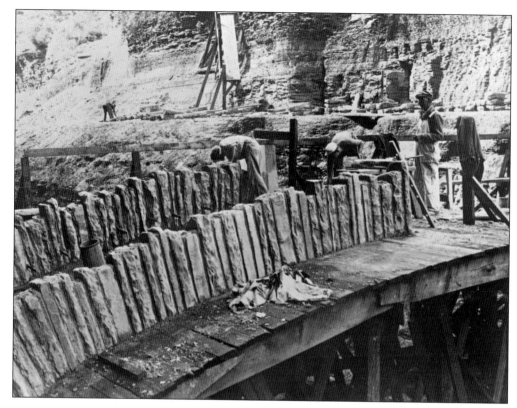

Stone from the local quarries formed the arch on top of the wood decking (above). The stones were brought to the bridge site on a wooden track and then hauled to the proper spot by hand. A stonemason oversaw the process. With the initial stone arches completed, work on the stone footing, final concrete deck, and the bridge walls began, starting at the eastern end (below). (Both, LSP.)

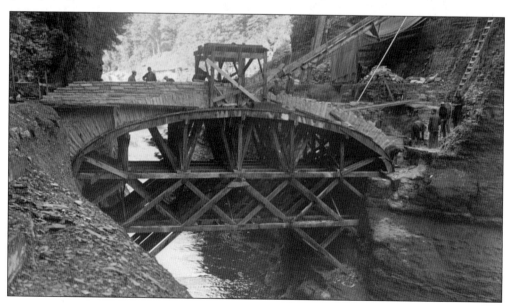

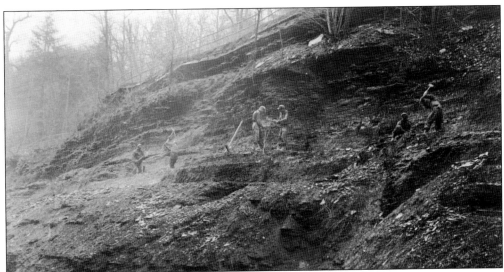

According to newspaper reports, the bridge itself was completed in the fall of 1935. But access trails on both sides of the bridge were still under construction in July 1936. Above, Lower Falls enrollees work on what will become a flight of stone steps leading from the Lower Falls picnic area to Table Rock. Once that work was done, more steps had to be built from Table Rock to the entrance of the new footbridge, seen below. The west side work was completed in 1937. (Both, LSP.)

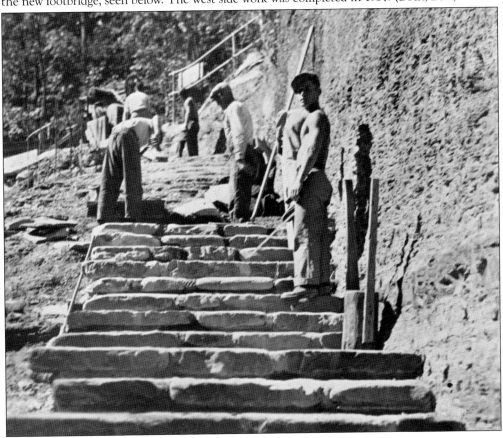

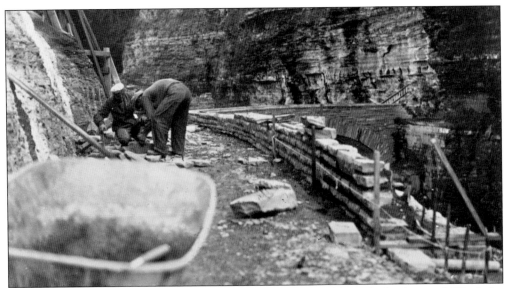

Above, a crew works on the trail east of the new footbridge, visible in the background. The ledge for the trail was cut from the cliff early in the project. It took until the summer of 1938 to complete the eastern trail from the bridge to the Carrying Road. The stone wall was heavily damaged in the 1972 flood, but the footbridge survived. Below, the finished bridge and the accompanying trail systems were dedicated as the Edward H. Letchworth Trail in June 1939. At the dedication, which honored William Pryor Letchworth's great-nephew, Commissioner Wolcott J. Humphrey also paid tribute to the CCC men who had done so much work on the bridge and the rest of the park. At the closing of the ceremonies, he stated, "We shall be indebted to their work for a great many years." (Both, LSP.)

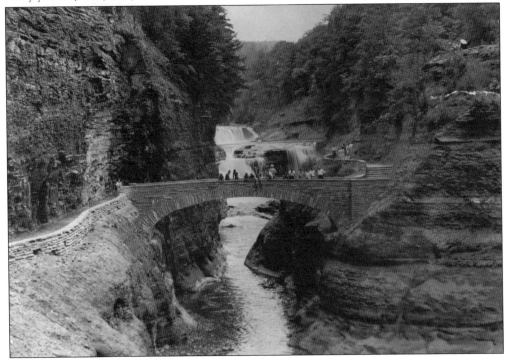

*Five*

# LETCHWORTH PARK'S CCC LEGACY

Park officials once estimated that each year of CCC work accomplished 10 years worth of development for Letchworth Park. Despite this success, national politics, economics, and evolving domestic needs led to changes in the camp, and the program eventually ended in 1942. As the last issue of St. Helena Camp's newspaper unhappily depicts, the Letchworth Camps were ordered closed, one by one. (LSP.)

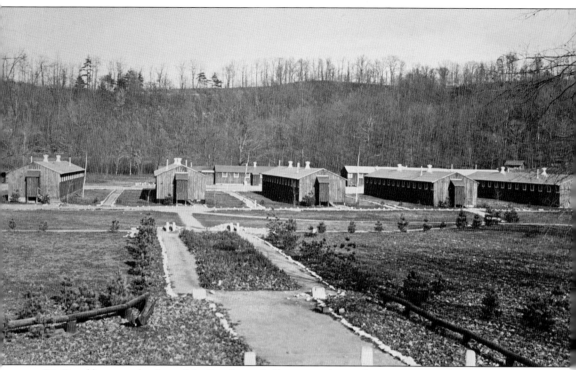

Big Bend became the first of the Letchworth Camps to close, when its personnel were transferred to a camp in Cohocton, New York, on October 25, 1935. When this photograph was taken a few weeks later, park employees had removed the decorative gates (page 19), cannon, fences, and other equipment from the empty camp. The following year, a federally funded, state-run transient camp was established at Big Bend. Designated Work Camp 9, the unemployed workers carried out projects under the auspices of the Works Progress Administration (WPA), including finishing the Great Bend Road, building a pond and stone bridge at Inspiration Point, and enlarging two parking areas near the museum. The work camp operated until the spring of 1942. The Army was reported to be interested in taking over the camp in August 1942, but the buildings were removed that fall. (LSP.)

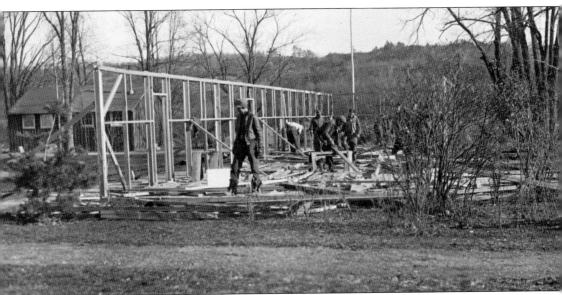

St. Helena was next, with its members leaving for other camps on April 30, 1936. The camp's supplies and equipment were sent to Schenectady, New York. A caretaker was assigned to watch over the empty buildings, as there was talk of turning them into a Boy Scout camp. The New York State Education Department held a weeklong extension school program at the camp that August; a month later, the two-day Wyoming County Fair was held at the camp. A local newspaper declared the fair "bigger and better" than previous years and "highly successful from every point of view." The poultry exhibits reportedly "filled two of the large barracks" of the former camp. That was, however, the last hurrah. In January 1937, enrollees from the surviving camps razed most of the buildings, salvaging the lumber for other projects. One was left for park use but later removed. This photograph is captioned "Razing the Administration Building of NY No. 37." (LSP.)

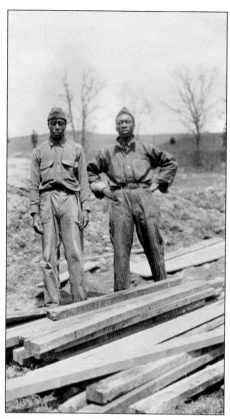

The order to disband was received by Gibsonville's Company 213 in April 1937. An African American company arrived on April 27, mostly new enlistees from Camp Dix, New Jersey, with a few veterans from a camp in Birdsall, New York. Two members of the new Gibsonville company pose by a pile of lumber (left). That company only stayed for six months. In October 1937, the men returned to Camp Dix, and the Gibsonville camp was officially closed. Some of the barracks (below) were still standing in 1943 when "Bohemian laborers" were reportedly housed at the camp. The following year, the "Gibsonville Girls" arrived. They were young women, ages 18 to 35, who paid $1 a week for room and board at the former CCC camp while earning money working at the canning factory in nearby Mount Morris, New York. (Both, LSP.)

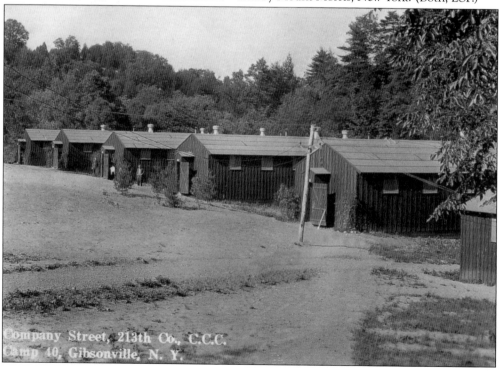

Company Street, 213th Co., C.C.C. Camp 40, Gibsonville, N. Y.

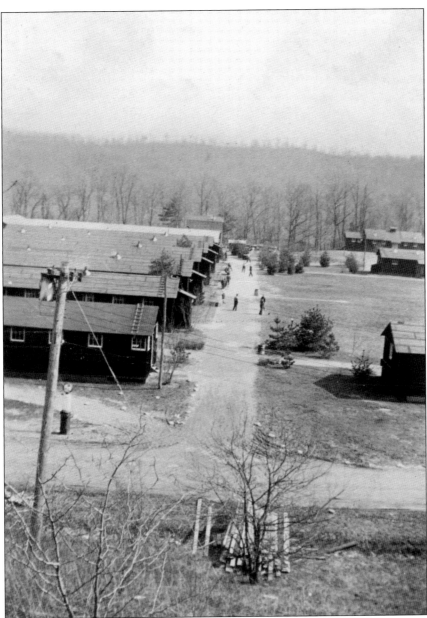

The Lower Falls Camp closed in October 1941. A few buildings were reportedly taken down in 1942, but most of the camp was standing when it was converted to a prisoner-of-war camp in June 1944. The *Perry Record* describes the conversion: "The task of preparing the camp involves considerable work and includes the erection of a barbed wire stockade with a guard house tower on each of the four corners . . . construction of an electric line around the stockade with the installation of flood lights." The CCC barracks shown here would be among the buildings. "Only the five barracks of the camp are enclosed by the barbed wire stockade although the kitchen and mess hall are in a separate enclosure. Other camp buildings outside of the enclosure are used by camp personnel." The German prisoners arrived on July 3, 1944, and remained at the camp until January 1946 when the camp closed. The buildings were taken down later that year and sent to Buffalo, New York, for veterans' housing. (LSP.)

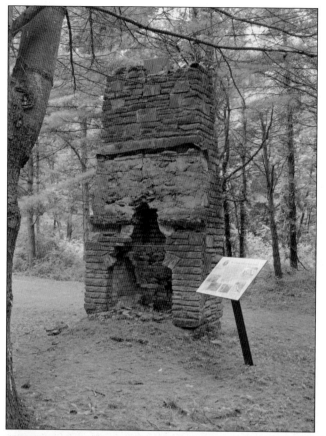

Remnants of the four Letchworth CCC camps can still be found eight decades later. Stone chimneys, like the one at the former site of the Big Bend Camp near modern Cabin Area E, can still be found (left). This chimney, along with the one from Gibsonville, are, at the time of this writing, the focus of preservation efforts. The lower parking area at St. Helena marks the spot where that camp once stood. As seen in this modern image, a narrative board and permanent markers show visitors the location and layout of the Lower Falls Camp (below). But echoes of these camps and the men that served in them are not just found in these locations. Throughout the park, examples of their physical legacy can still be seen. (Left, photograph by Emily Cook.)

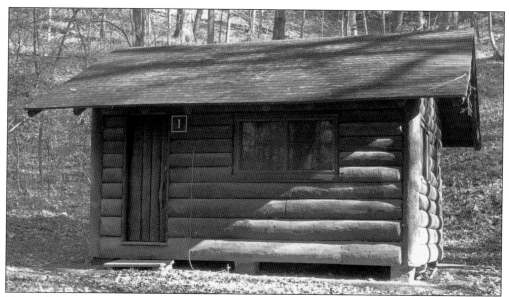

Many of the CCC projects described in chapter 4 survive to this day. For example, modern-day cabin areas B, C, D, and E were all built by the CCC. Many of the original cabins are still in use. This photograph of a cabin in Area E was taken in the spring of 2014. It is among the first ones built by the Big Bend Camp.

Because of the heavy use by several generations of park visitors, many of the CCC structures have undergone necessary repairs and renovations. When park employee Kent Cartwright was working on Cabin E4, he discovered that enrollees had inscribed their names in the wet concrete of the cabin's piers. The signature of "M. Lindquist" is dated October 1, 1933. (Photograph by Kent Cartwright.)

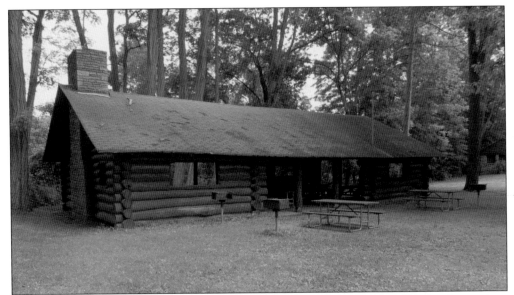

Today, many of the park's popular shelters are the work of the CCC. Countless family reunions and group picnics have been held at the Parade Grounds (Barrack Grounds) shelter, seen on page 85. The building still has its chestnut logs and flagstone floor, though the original bathrooms were removed and replaced by a stone comfort station just visible to the far right in this 2014 photograph. (Photograph by Emily Cook.)

Another popular reminder of CCC days are the park's stone tables. Although some tables were completed after the camps closed, many were built in the 1930s. The table in this 2014 photograph was built by men of the Big Bend Camp. At the time of this writing, a project is underway to restore several of the original tables near the Parade Grounds shelter.

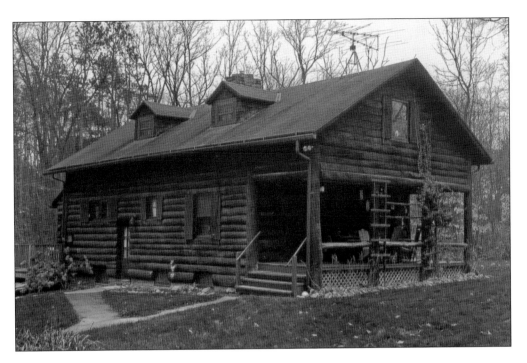

Except for the Highbanks Recreational Area, which was developed in the north end of the park in the 1960s, it is difficult to spend a day in the park without seeing or using something that comes from the CCC. In addition to cabins and shelters, many of the CCC trails, walls, and other structures are still in use. Two examples pictured in these modern images are (above) the Cabin Area C caretaker's house, built by the Gibsonville Camp (page 90), and (below) the St. Helena Picnic Shelter (page 95). All the picnic areas from the Hogsback area south to the Upper Falls were either created or developed by the camps. The evergreen forests north of Wolf Creek are another part of the park's CCC legacy.

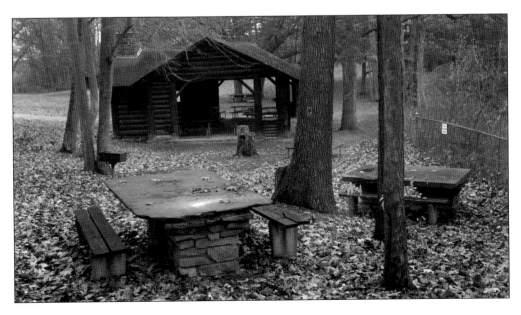

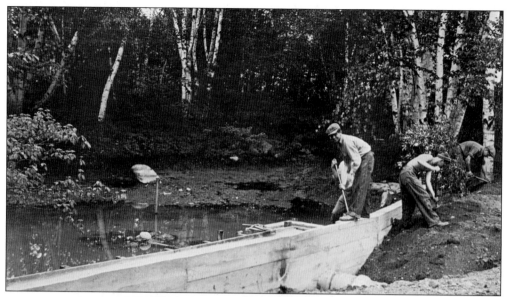

Some CCC projects are easily overlooked by visitors. Several reservoirs and water systems built by the enrollees are still in use in various parts of the park but are not easily seen. One project, built with CCC help, is the Birch Reflecting Pond. It still can be found on the west side of the main park road just north of the park's administration building. (LSP.)

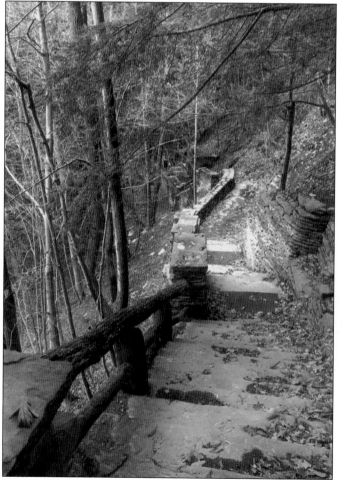

The stone steps cut into the cliff walls above Table Rock (page 111) are still in use today, as seen here. As one would expect, some of the original projects, including stone walls and steps, have been renovated over the years by park workers and contractors. That they still exist after nearly 80 years of hard use and weathering bears testimony to the quality of the CCC work.

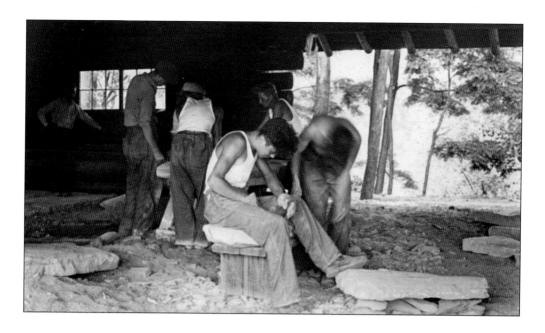

The Civilian Conservation Corps also left a human legacy, a generation of young men who believed in the motto "We can take it!" Enlistee Joe Cravotta writes in the July 10, 1936, issue of the *Genesee Gazette* that the CCC was the "turning point of our lives, the point of emergence from the carefree and mischievous youth to the serious minded and level-headed citizen of the U.S.A." Many CCC veterans acquired skills and attitudes that would later provide a good living for them and their families (above). The program also, as CCC veteran John Branciforte recalled, "provided . . . a ready military pool accustomed to regimentation when WWII began." Like many of his CCC buddies, Roy Gath (below, center) served in World War II. This photograph from his album was taken in 1943. (Above, LSP; below, NHS.)

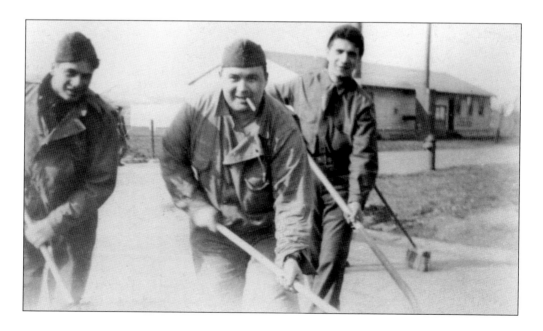

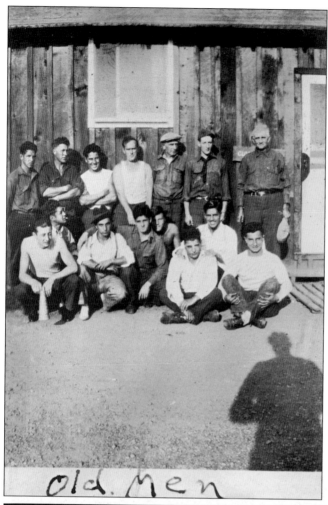

old Men

Roy Gath labeled the photograph at left "Old Men" when he took it in 1935 or 1936. Young Roy probably never dreamed that he would someday sit with the old men, former enrollees who attended the first Letchworth CCC reunion in August 1983. Gath is second from the right on the first row in the photograph below, taken by Clark Rice of Perry, New York. Annual reunions continued over the years, and a CCC alumni group consisting of veterans and their families took shape. These gatherings gave veterans a chance to see their old camp comrades and share memories. The reunions also provided families, the park, and the general public a chance to learn more about the Civilian Conservation Corps experience. (Both, NHS.)

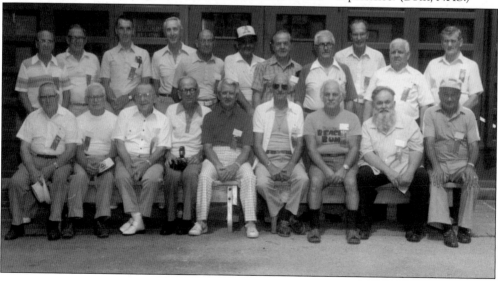

At that first reunion, Letchworth Park dedicated one of New York's first CCC memorials, a tall flagpole with a stone base near where the Lower Falls Camp gate once stood. The memorial plaque at the base pays tribute to the CCC, "whose dedication helped to develop this park." Two decades later, another CCC memorial, seen in this modern image, was erected nearby (right). A project of the group Friends of Letchworth Park and the CCC Alumni, the statue of a CCC worker captures the strength and determination of the young men who served in the Letchworth Camps. A year earlier, some of the surviving enrollees completed their last CCC project (below). With the help of park officials and members of the Friends of Letchworth Park, they helped to lay the stones of what would become the base of the new statue. (Below, LSP.)

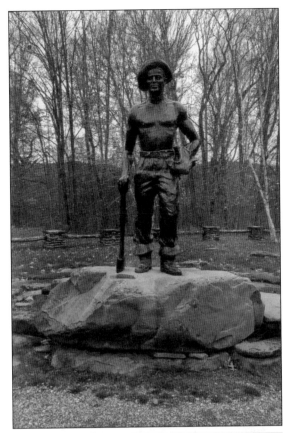

The park's last CCC reunion was held in the CCC-built Lower Falls Shelter (page 105) on August 2, 2014. Three alumni were in attendance; they are, from left to right, veteran John Maniscalco of Geneseo, New York, Lawrence Kelly of Castile, New York, and Garland Cummings of Webster, New York, whose father was an LEM at the Big Bend Camp. Behind them, holding the cake, is Letchworth Park manager Roland Beck, who shares a deep appreciation for the CCC. "Letchworth today is a direct result of the projects that the CCC had accomplished so many years ago," Beck states, "and it is amazing to me that many of these features still stand today." Although the CCC generation is rapidly fading away, its legacy will not be forgotten. The many CCC features and sites, a permanent museum exhibit, narrative signs, interpretive historical walks, and an annual CCC recognition day will all continue to remind visitors of the remarkable work of the men who, as stated by the late Edward Hamilton, former general park manager, "laid the foundation for the modern park."

# BIBLIOGRAPHY

Anderson, Mildred Lee Hills. *Genesee Echoes: The Upper Gorge and Falls Area from the Days of the Pioneers.* Dansville, NY: F.A. Owen Publishing Company, 1956.

Breslin, Thomas A., Thomas S. Cook, Russell A. Judkins, and Thomas C. Richens. *Letchworth State Park.* Charleston, SC: Arcadia Publishing, 2008.

Cohen, Stan. *The Tree Army, A Pictorial History of the Civilian Conservation Corps, 1933–1942.* Missoula, MT: Pictorial Histories Publishing Company, 1991.

Cook, Thomas S. *Nunda, Portage, and Genesee Falls.* Charleston, SC: Arcadia Publishing, 2011.

Hamilton, Edward A. "The Civilian Conservation Corps at Letchworth State Park, 1933–1941." Master's thesis, Slippery Rock University, 1984.

Letchworth Park Archives, Letchworth State Park, Castile, NY.

Maher, Neil M. *Nature's New Deal, The Civilian Conservation Corps and the Roots of the American Environmental Movement.* New York: Oxford University Press, 2008.

New York State Archives, Albany, NY.

Oliver, A.C. Jr and Harold M Dudley. *This New America, The Spirit of the Civilian Conservation Corps.* New York: Longmans, Green & Co., 1937.

Salmond, John A. *The Civilian Conservation Corps, 1933–1942.* Durham, NC: Duke University Press, 1967.

US National Archives, National Archives and Record Administration, College Park, MD.

www.ccclegacy.org

www.fultonhistory.com

www.letchworthparkhistory.com

*Your CCC, A Handbook for Enrollees.* Washington, DC: Happy Days Publishing Co., n.d.

# Discover Thousands of Local History Books
## Featuring Millions of Vintage Images

Arcadia Publishing, the leading local history publisher in the United States, is committed to making history accessible and meaningful through publishing books that celebrate and preserve the heritage of America's people and places.

Find more books like this at
**www.arcadiapublishing.com**

Search for your hometown history, your old stomping grounds, and even your favorite sports team.

Consistent with our mission to preserve history on a local level, this book was printed in South Carolina on American-made paper and manufactured entirely in the United States. Products carrying the accredited Forest Stewardship Council (FSC) label are printed on 100 percent FSC-certified paper.

MADE IN THE USA